The Acquisition and Exhibition of Classical Antiquities

A symposium held at the Snite Museum of Art,

University of Notre Dame, February 24, 2007

Organized by Robin F. Rhodes and Charles R. Loving

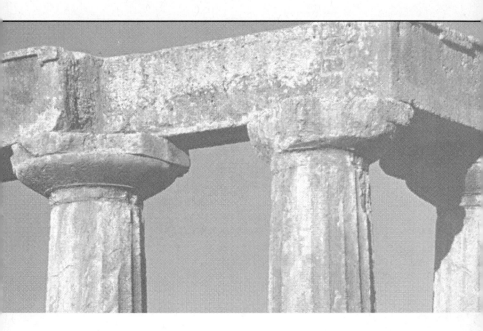

The

Acquisition

and

Exhibition

of

Classical Antiquities

Professional, Legal, and Ethical Perspectives

Edited by

Robin F. Rhodes

University of Notre Dame Press
Notre Dame, Indiana

Copyright © 2007 by University of Notre Dame
Notre Dame, Indiana 46556
www.undpress.nd.edu
All Rights Reserved

Reprinted in 2011 1 39373

Manufactured in the United States of America

Front Cover Image: 6th c. BCE temple on Temple Hill in Corinth.
Photo courtesy of Robin F. Rhodes.

Back Cover Image: Terracotta mask of Dionysos, 4th c. BCE.
Courtesy of the Corinth Excavations, American School
of Classical Studies at Athens.

Image facing title page: 6th c. BCE temple on Temple Hill in Corinth
(detail). Photo courtesy of Robin F. Rhodes.

Library of Congress Cataloging-in-Publication Data
The acquisition and exhibition of classical antiquities : professional,
legal, and ethical perspectives / edited by Robin F. Rhodes.
 p. cm.
ISBN-13: 978-0-268-04027-7 (pbk. : alk. paper)
ISBN-10: 0-268-04027-3 (pbk. : alk. paper)
1. Cultural property—Protection. 2. Cultural property—Protection—
Law and legislation. 3. Cultural property—Protection (International
law) 4. Archaeological thefts. 5. Archaeology—Moral and ethical
aspects. 6. Archaeologists—Professional ethics. 7. Antiquities—
Collection and preservation—Moral and ethical aspects. 8. Greece—
Antiquities—Collection and preservation. 9. Rome—Antiquities—
Collection and preservation. 10. Middle East—Antiquities—Collection
and preservation. I. Rhodes, Robin Francis.
 CC175.A28 2007
 069'.5—dc22
 2007035546

∞ *The paper in this book meets the guidelines for permanence and
durability of the Committee on Production Guidelines for Book Longevity
of the Council on Library Resources.*

To Douglas and Marjorie Kinsey

Contents

Preface

CULTURAL PROPERTY AND ITS STEWARDSHIP HAVE long been concerns of museums, archaeologists, art historians, and nations, but recently the laws, policies, and consequences of collecting and exhibiting antiquities have also attracted the broader interest of the media and the public. This has been the result, in part, of several thefts and high-profile trials, and various foreign governments are now demanding the return of specific antiquities to their countries of origin.

These new circumstances have provided the interest and opportunity to open the question further, to move beyond the rather clear-cut moral response to looting, and on to the consideration of the more subtle implications of buying, selling, and exhibiting antiquities. To whom should antiquities belong? What constitutes legal ownership of antiquities? What laws govern the importation of antiquities into the United States? What circumstances, if any, demand the return of those antiquities to their nation of origin? Should all antiquities be returned to their place of origin if they can be properly cared for and displayed there? What are the consequences of the looting of sites and the illicit trade in antiquities? of the demands for repatriation of antiquities? Is there a consensus among archaeologists about these issues? among museum directors? Are new acquisition policies and new strategies of exhibition demanded? Do archaeologists and museum directors share the same opinions? How can the public best be educated about these issues?

This symposium on the acquisition and exhibition of classical antiquities addressed these and other questions, through presen-

tations by art museum directors and curators, archaeologists, art historians, and scholars of international law.

We would like to thank Vice Provost Jean Ann Linney for her participation in the symposium and for her help in presenting our publication proposal to the University of Notre Dame. We are also grateful to Dr. Barbara Hanrahan, the director of the University of Notre Dame Press, for accepting the proposal, for squeezing it into an already-set publication schedule for the year, and for making it possible to publish these proceedings quickly. We would also like to thank Rebecca DeBoer of the Press for the speed and thoroughness with which she has copyedited this manuscript, and Alexis Belis, a long-time crew member of my Corinth Architecture Project, for her valuable help in the formatting of footnotes and bibliographies.

Introduction

Robin F. Rhodes, Moderator

I WOULD LIKE TO THANK ASSOCIATE PROVOST AND Vice President Jean Ann Linney for welcoming us all to the Annenberg Auditorium of the Snite Museum of Art at the University of Notre Dame. I, too, would like to welcome you to our symposium entitled "The Acquisition and Exhibition of Classical Antiquities: Professional, Legal, and Ethical Perspectives." It promises to be a lively discussion of a complex problem of great topical interest and of global significance.

Before attacking the problem, I'd like to thank all who have been instrumental in the realization of this project, beginning with the University of Notre Dame and all our sponsors here: the Nanovic Institute for European Studies; the Institute for Scholarship in the Liberal Arts; the College of Arts and Letters; the Office of Research; the Department of Art, Art History, and Design; the Department of Classics; and, of course, the Snite Museum of Art. I would also like to offer thanks to my co-organizer, Charles R. Loving, director of the Snite Museum, who offered the Snite for the symposium venue and has throughout offered his own expertise as a museum director and that of his fine staff for the tasks of publicity and the practicalities of facilitating such a production; to Eleanor Butterwick, assistant director of the Nanovic Institute, whose innocent request for the name of a lecturer set a semi-giant snowball in

motion and whose organizational skills put our meetings on the calendar and made sense of them in the minutes that dutifully followed; to Harriet Baldwin, the academic conferences administrator for the College of Arts and Letters; and to all the members of the Notre Dame community, including students, who have volunteered their help to us. I would also like to thank all the members of the Notre Dame and Saint Mary's community who are contributing papers or responses to papers. Finally, and especially, I am grateful to those presenters who have come from elsewhere, in fact, from as far as Greece and Sicily, to share their ideas and ideals with us here today. It is a distinguished group, many of whom have already become familiar and important voices in this critical international debate. To preserve as much time as possible for papers and discussion, we have printed and distributed short bios of each of the participants, so my spoken introductions of each will simply be name and institutional affiliation.

It seems that just yesterday many of you in the audience and, in fact, among the symposium participants were here in the Snite for the opening of the Corinth Temple Exhibit and for its accompanying symposium, "Issues in Architectural Reconstruction," held at Bond Hall of the Notre Dame School of Architecture. For the people directly involved, those two projects, particularly the exhibition, were nearly as gratifying for their cooperative, interdisciplinary effort as for their content, and today's symposium is similarly the result of a community effort. The idea for today's symposium is in fact indebted in a real way to last year's exhibition and symposium. It was inspired by a request I received a year ago from Eleanor Butterwick—a week before the opening of the Corinth Temple Exhibit—to find for the Nanovic Institute a speaker from the Italian government who might address the fast-expanding story of Marian True and the Getty and Italian antiquities, and then a week later, by the success of the Reconstruction symposium. In the flush of all the good energy and discussion engendered by the symposium, including enthusiastically positive responses from Nancy Bookidis and Charles Williams to the suggestion that rather than

bringing over a single speaker we try to organize a symposium on issues of cultural property, *and* magically forgetting all the effort involved in pulling together the Reconstruction symposium, I ran back to Eleanor with the suggestion. She also was enthusiastic and, knowing the ropes, encouraged me to formulate a description of the symposium and apply to the Nanovic for a supporting grant. The application was successful, I began contacting potential symposiasts, Charles Loving offered the Snite and its services to the symposium, and we began regular planning meetings. Nancy Bookidis and Charles Williams had already committed, Nancy introduced me to Patty Girstenblith and told me about C. Brian Rose's lectures to U.S. troops, and back when the Nanovic still thought they would be satisfied with a single speaker, I had already decided to suggest Stefano Vassallo. For some time James Cuno and Malcolm Bell had been clear, thoughtful voices in the debate—in fact, Jim had spoken here in this auditorium on the issue a year or two earlier—and Charles Loving was confident that he would be willing to return for the symposium, as, later, he was also hopeful that Kimerly Rorschach would be willing to participate. Finally, Charles Rosenberg introduced me to the work of a new professor of international law at Notre Dame, Mary Ellen O'Connell. Once the invitations had been made and acceptances returned, it was time to contact and collar our broad range of respondents, mainly from Notre Dame and Saint Mary's, and I am grateful to say that everyone I contacted enthusiastically accepted.

Afterwards, and of value in formulating the final goals of this symposium, Charles Loving and I attended the conference "Museums and the Collecting of Antiquities—Past, Present, and Future" held in early May 2006 at the New York Public Library, sponsored by the Association of Art Museum Directors and co-organized by our own panelist here, Jim Cuno.

The overall rationale in assembling this particular group of speakers and respondents has been to represent a broad range of perspectives and a broad range of issues. Among the participants are three museum directors, two museum curators, two lawyers,

one architect, three art historians, three art historian/archaeologists, one anthropologist/archaeologist, and three straight field archaeologists. The morning session will be devoted to the presentation of four perspectives on the acquisition and exhibition of antiquities, that of the director of a major American art museum, that of an American field archaeologist, that of an American lawyer, and that of the director of an American university art museum. The afternoon session will be devoted to additional perspectives and case studies. The first presentation will be by an archaeologist representing the Italian government; the second will discuss the framework of international law surrounding the destruction of cultural property in Iraq and Afghanistan; the third, a description of the robbery of a site museum in Greece, the practicalities of response to such a crime, and the consequences of the robbery itself and of taking swift and organized action; and the fourth will describe the training in the responsibilities of cultural property one archaeologist is volunteering to American troops before their deployment in Iraq and Afghanistan. Time has been set aside at the end of the morning session for questions and comments from the audience and from the panelists, and following the afternoon session the panelists and the audience will engage in an open discussion. Since there will be no discussion immediately following a paper and response, I encourage you to jot down questions and comments during and after each paper so they can be sure to be addressed during the open sessions.

The topic of today's symposium is the acquisition and exhibition of classical antiquities from professional, legal, and ethical perspectives. It was organized in direct response to a growing concern among professionals in the world of museums and archaeology and now, with the high-profile, glamorous prosecutions by the Italian government of Marian True of the Getty Museum and Robert Hecht, a notorious American antiquities dealer, a growing concern among the popular media and the general public.

Today's focus will be on the classical world, but the same issues could be discussed in relation to the antiquities of any geographical region or chronological period. Of central concern is the looting of archaeological sites and the policies of sites, governments, and museums that encourage or *dis*courage such practice. Because archaeologists are historians who continually attempt to refine the understanding of ancient history through the ever-more-detailed contextualization of artifacts, and museums are collectors for whom, traditionally, the intrinsic value of an object tends to outweigh its value as a historical and cultural source, these two professions have found themselves, to one degree or another and depending upon the individuals and institutions, in conflict. Perhaps the most famous of those conflicts arose thirty-five years ago over the purchase by the Metropolitan Museum of Art in New York of a late sixth-century BCE krater painted by the Athenian Euphronios. Its pristine condition and lack of convincingly traceable provenance, together with its delivery by Robert Hecht himself, led many, if not most, to believe that it had been recently robbed from an Etruscan tomb. When Thomas Hoving, then director of the Met, paid a cool million for the pot it became the first bonus-baby antiquity. The celebrity accorded "The Vase," as it soon became known, by its price, by the cloak-and-dagger atmosphere surrounding its provenance and journey to the Met, and by the manner of its exhibition—all alone in a spotlight, standing on a pedestal in a large, purple-draped room—transformed it into a blockbuster show and attracted viewers from all over the world. This was antiquity as big business, not just business from admissions to the Met, but also from the *potential* looters and dealers saw for many more future blockbusters. Here was a clear example of how the looting of antiquities and the destruction of archaeological sites was directly connected to museums: via the art market. Supply and demand. It also laid out as a paradigm for the world to see the complete de-contextualization of an important ancient object: not only had its archaeological context been obliterated by the secrecy surrounding its theft, but the museum seemed through the strategy of

its display to glorify it as an immensely valuable object whose inherent beauty and rarity overshadowed any responsibility for the preservation or reconstruction of its original cultural context. Yet even in the broadest of strokes the context of this vase is critical in regard to what it might tell us about antiquity: if this late sixth-century BCE vase came from the kitchen of a late sixth-century Athenian house it tells one story; if it was found in a fourth-century BCE or even a sixth-century BCE Etruscan tomb in Italy, it tells something altogether different. For archaeologists whose meticulous field methodologies have been evolved for the express purpose of recovering context as completely as possible in order to understand the objects found in that context in as much detail as possible, the actions of the Metropolitan warranted a crusade. Last year, Phillipe de Montebello, the present director of the Metropolitan, agreed to return the vase to Italy.

The antiquities market and the looting of cultural property are nothing new. They have been around forever, and it might be argued that their long-term consequences have not been *completely* negative. It was the sacking of Syracuse at the end of the third century BCE and especially of Corinth in 146 that did much to create a taste for things Greek (including antiquities) in the Romans and that altered the content and form of their art forever. As this Hellenized version of Roman art is what was rediscovered and revived in the Renaissance and passed down in the western world, it could be argued that to some extent our own language of art and architecture and our appreciation and preservation of classical Greece as our common cultural ancestor can be traced back to early examples of the looting of cultural property.

The questions surrounding cultural property are not simple. Yes, everyone agrees that ancient sites should not be looted and that recently looted objects should not be purchased or exhibited by museums, but *how* recently? Should antiquities be proven to have been in a known collection or on the market for at least ten years before it is morally acceptable to buy and exhibit them? Or since 1970, the date the UNESCO Convention on the Means of Prohibit-

ing and Preventing the Illicit Import, Export and Transfer of Ownership of Cultural Property was written? And what kind of documentation constitutes "proof"? The history of the object provided by a "reputable dealer"? Or does the inherent conflict of interest there mandate time-consuming, independent research into the object before deciding to acquire it? If an important but unprovenanced object comes onto the market is it better for a museum to buy it and display it than have it disappear into a private collection where it will be inaccessible for the foreseeable future? Do museums perform a public service by purchasing such objects or simply encourage the looting of cultural property by encouraging the art market? Should scholars include in their publications insufficiently provenanced objects? And what exactly *is* the property of a culture, and when should it be returned? If a museum adopts one of these dates in its policy of purchase, should it return those objects already purchased that do not conform to that policy? Is it the modern Greeks alone who are cultural heirs to the art and architecture (or, for that matter, the literature and philosophy) of the classical Greeks, or is it the western world as a whole? In nations that do little to live up to the responsibilities of protecting cultural heritage, is it better to let that heritage be destroyed or disappear into private collections, or to collect it for museums in countries that are more responsible? If by the standards of international law one nation illegally invades another, is the invader legally responsible for any destruction of cultural property that results from the invasion or from the civil and political instability it inspires?

On one side of this debate have stood archaeologists, on the other the universal museum, one of the great institutions of the western world, first developed in the nineteenth century and still central to our cultural lives. In fact, many of us owe our most exciting and valuable experiences with certain cultures of different times and places to such museums. How many classical archaeologists were first inspired to study classical art and culture by discovering the classical sculpture and painting of the Metropolitan or of the Boston Museum of Fine Arts? And how many of us first recognized

uncanny similarities between widely separated cultures and were inspired with a sense of the commonality of all humanity by the juxtaposition of art in museums? But can their historically questionable collection policies be justified by the fact that more people will see an object in an international museum than in a site storeroom, or that by buying antiquities on the market they remain accessible to the public and the scholarly world? How do we reconcile the great educational contributions of these institutions with what some have described as a colonialist attitude that has at times encouraged the pillaging of the antiquities of other nations?

This crisis has inspired spirited, at times vitriolic exchanges among museum directors, archaeologists, scholars of international law, and representatives of governments and institutions of various nations. But it has also inspired more methodical attacks of the problems: new initiatives for cultural exchange (as in the deal brokered between the Met and the Italian government, whereby the Euphronios vase is returned to Italy in exchange for the extended loan of Italian antiquities that would otherwise never be seen in the United States); new exhibition strategies; new literature and symposia that directly engage, confront, and interpret the national and international laws that pertain to cultural property; new awareness of the mechanics of the illicit trade in antiquities and concerted efforts to spread information and training about proper precautions and procedures to follow to prevent looting and to prevent the trafficking of the looted; and efforts to educate the general public on the issue, and thus to instill broadly an appreciation and respect for foreign cultures, their creations, and their laws.

All of these issues, as well as others, will be touched upon today, or addressed in depth, and it is my hope that instead of simply fanning the flames of disagreement, further arming and isolating ideological fortresses, these papers and responses and ideas will move the discussion of our responsibility toward antiquities one positive step further, and that at the end of the day we all feel encouraged that there is some common ground on which all of us stand. Welcome to the symposium and let it commence.

Art Museums, Archaeology, and Antiquities in an Age of Sectarian Violence and Nationalist Politics

James Cuno

For nearly fifty years, archaeologists and their supporters have lobbied for national and international laws, treaties, and conventions to prohibit the international movement in antiquities. For many of those years, U.S. art museums that collect antiquities have opposed these attempts. The differences between archaeologists and U.S. art museums on this matter have spilled out into the public realm by way of reports in newspapers and magazines, public and university symposia, and specialist—even sensationalist—books on the topic.

The differences have focused on the principle and practice of acquiring unprovenanced antiquities; that is, antiquities with modern gaps in their chain of ownership, whose archaeological context is not known. The arguments against museums acquiring unprovenanced antiquities are often legalistic. Is the antiquity in the care of a museum there legally or illegally? Was it exported from its presumed country of origin legally or illegally? Laws are made by governments. National export and ownership laws are made and enforced by national governments. Any consideration of the legalistic arguments against museums acquiring unprovenanced antiquities

must take into account the nationalist agenda of national export and ownership laws.

National export and ownership laws are meant to control the movement of cultural property that a given nation claims to be of great importance to its national identity and esteem. They are retentionist laws by intent, meant to retain a nation's self-proclaimed cultural property for itself. Export and ownership laws have increased in number dramatically over the past sixty years, just as the number of nation-states has. When the United Nations was founded in 1946, there were 51 member nation-states. There are now 191. The majority of these nations have retentionist cultural property laws: either ownership laws, in which antiquities found in the ground within the modern borders of the modern state are declared state property; export laws, in which specific kinds of objects, even if privately owned, cannot be exported from the modern nation-state without official permission; or hybrid laws. Most of these laws have come into effect only since 1947; and most of these date only from 1970.

Under the auspices of the United Nations, individual nations have joined together to pass conventions that seek to further control access to one nation's self-proclaimed cultural property, including antiquities. The Stanford law professor and dean of cultural property law in the United States, John Henry Merryman, has been critical of these conventions, noting that "[s]keptics might conclude that this Convention [UNESCO 1970], in the name of cultural property internationalism, actually supports a strong form of cultural property nationalism. It imposes no discipline on a State's definition of the cultural property that may not be exported without permission. It leaves States free to make their own self-interested decisions about whether or not to grant or deny export permission in specific cases. . . . In this way, the Convention condones and supports the widespread practice of over-retention or, less politely, hoarding of cultural property."[1]

1. J. H. Merryman 2005, p. 22.

Cultural property is a political construct: it is whatever one sovereign authority claims it to be. And yet it is discussed as if it were almost natural, even mystical, deriving from "a people." (UNESCO 1970 even refers to the mythical, magical, possibly racist but certainly nationalistic "*collective genius of a nation.*") It is said to be central to a people's identity; and then not just to a people's identity (a national people, an imaginary community) but to people themselves, individually—to be part of them, to *give* them their identity, to help them understand who they are, to connect them to their history, to enrich their self-esteem as being of a *particular people.*

Is this true of cultural property? Is this true even or especially of antiquities, even of those antiquities found within the territorial boundaries of a modern nation-state and claimed by that nation-state as its cultural property, the nation-state of which a person is a national, a part of the collective national identity?

A Lebanese man was quoted as saying recently, in the midst of the sectarian violence within his country and the conflict between Hezbollah and Israel, "If you cut me, you see Lebanon. You see the prophet Muhammad, you see Imam Ali, you see the cedars. You see everybody in my country in my heart."[2] He didn't say the ancient Roman ruins or antiquities within Lebanon's borders. The stuff of his culture—*his* cultural property—evidently does not include antiquities before the Muslim conquest (and certainly not the great sarcophagi taken from Sidon by the Ottomans in the last years of the Empire and now the pride of the Istanbul museum and a protected part of Turkish cultural property). The culture of the Lebanese man is not even the same as that of a Lebanese Sunni's or Lebanese Christian's culture. Culture is personal. It is not national. People make culture. Nations don't.

Antiquities are often from cultures no longer extant or of a kind very different from the modern, national culture claiming them. What is the relationship between, say, modern Egypt and the

2. A. Shadid 2006.

antiquities that were part of the land's Pharoanic past? The people of modern Egypt do not speak the language of the ancient Egyptians, do not practice their religion, do not make their art, wear their dress, eat their food, or play their music, and they do not adhere to the same kinds of laws or form of government as the ancient Egyptians did. All that can be said is that they occupy the same (actually less) stretch of the earth's geography.

But still, these facts didn't prevent the rise of "Pharaonism" in Egypt in the last decades of the nineteenth century. Until then, and despite easy contact with extraordinary remains of ancient, Pharaonic Egypt all around them, Egyptians were uninterested in their land's pagan past. Their country's significant history, so its people reasonably believed, began with the advent of Islam. But this all began to change with their increased awareness of outsiders' (Europeans') interest in Egyptian antiquities. Napoleon's savants documented Pharaonic remains at the turn of the nineteenth century and were followed by numerous French, German, and British travelers and scholars over the next five decades. In 1868, Rifā Rafī al-Tahtāwī, an Egyptian scholar who spent years in France, published a book on the history of Egypt from the beginnings to the Arab conquest. As Bernard Lewis tells us, "[I]t was an epoch-making book, not only in the self-awareness of the Egyptian historiography, but also in the self-awareness of the Egyptians of themselves as a nation."[3] Many books followed, adding thousands of years to what the Egyptians knew about their own history, and a new kind of history-teaching was introduced in the schools.

This coincided with Egypt's separatist ambitions, as an increasingly independent province of the Ottoman Empire. It also marked a dichotomy in the Egyptian identity: between its Islamic, even Arabic language and culture, defined by its religious and communal life, and its imagined, descendant relationship with a Pharaonic past, which was defining itself in national and political terms. It also sparked opposition within the Arabic-speaking, Islamic world. The

3. B. Lewis 1998, p. 69.

Arabic word for Pharaonism is *tafar'un,* which literally means pretending to be Pharaonic. Other Arabic countries denounced the movement as a separatist attempt to create an independent Egypt within the greater Arab or Islamic world. And religious people criticized it as neo-pagan. Nevertheless, it encouraged new-found cults of antiquity in other Islamic countries, especially Iraq and Iran, where it reached its height in 1971. In that year, the Pahlavi shah held a great celebration in Persepolis to commemorate the 2,500th anniversary of the foundation of the Persian monarchy by Cyrus the Great. He was heavily criticized for both exalting the monarchy and proclaiming a common identity with a pagan past. As Lewis notes, "For the shah's religious critics, the identity of Iranians was defined by Islam, and their brothers were Muslims in other countries, not their own unbelieving and misguided ancestors."[4] The shah was overthrown in an Islamic revolution eight years later, and the Egyptian President Anwar Sadat was assassinated by a devout Muslim who declared "I have killed Pharoah!"

As a practice, archaeology is deeply embedded in national politics. As Neil Silberman reminds us, in his article in the *Oxford Encyclopedia of Archaeology in the Near East,*

> Consciously or subconsciously, archaeological interpretation and the public presentation of archaeological monuments are used to support the prestige or power of modern nation-states. . . . This is the result of the dominating role played by national governmental bodies, such as departments of antiquities, universities, and ministries of tourism and education, in the funding, legal oversight, and logistical support of archaeology. Indeed, national institutions often determine which of a nation's archaeological monuments will be preserved and presented to the public (through special legal decree or inclusion in national park systems) and often approve the contents of widely distributed interpretive information about them (in the

4. Ibid., p. 75.

form of school textbooks, on-site signage, and promotional tourist brochures).[5]

National governments regulate archaeologists working within their jurisdiction. They grant excavation permits, which determine which archaeological sites—*whose* past—is valued by governments as important to the nation. They sometimes contribute funding and management to approved archaeological sites. They set quotas for employing local people. And they mandate what if anything can be removed from archaeological sites and taken back to the host institutions of participating foreign archaeologists (typically foreign universities or museums). As these regulations are in the service of the state, they inevitably have a nationalist agenda.

At the American Anthropological Association meetings in Chicago in 1991, scholars presented papers examining the relationship between nationalism and archaeological practice. A subsequent publication of papers presented at the conference demonstrates just how nationalist politics work through archaeology in various ways: by setting the terms for archaeological practice; by encouraging archaeological work on only some areas of archaeological evidence (those that strengthen a modern nation's claim on an ancient and pure pedigree); and by providing "data" that can be misrepresented and manipulated by the state in the service of its nationalist agenda. There are numerous examples of this: German archaeology under the Nazis and Soviet archaeology under Stalin are only the most egregious ones. Other, more recent examples include the pursuit and use of archaeology in Greece and Macedonia; in Greece, Turkey, and Cyprus; in China; and in Turkey, which privileges Anatolian archaeology over archaeology on the Kurdish lands of southern Turkey, where stateless Kurds live, whose culture Turkey has been criticized for neglecting, even repressing.

Archaeology is controlled by the state and serves the state. As two British archaeologists working in Cyprus have written,

5. N. A. Silberman 1997, p. 103.

"overt political bias in archaeological research and interpretation is neither new or unusual: what has changed is the willingness of archaeologists to recognize such realities." And "[b]y its nature archaeology has always had an obvious political dimension, and nationalism—like ethnic or cultural identity—makes manifest the character of archaeology as a social, historical and political enterprise."[6]

Willingness of archaeologists to recognize such realities? The reevaluation of archaeology that occurred during the 1980s took the form of a critique of the processual theory of archaeology, which was dominant in the 1960s and 1970s. That theory embraced logical positivism as its guiding principle and positioned archaeology as a politically neutral, scientific enterprise. Where indigenous peoples (or nations) saw archaeological artifacts as cultural heritage of special relevance central to their identity, processual archaeologists saw archaeological artifacts as scientific data of special relevance to a universalizing database for the understanding of human behavior generally. Coming along in the 1980s, postprocessual theory criticized processual theory for its failures to understand the construction and political applications of knowledge. Influenced in part by the writings of the French philosopher Michel Foucault, postprocessual theory argued that intellectual knowledge and thought (like archaeology) are necessarily incorporated into the act of governing populations and social problems by subjecting them to analysis and become tools in the processes of government and administration. On these terms, archaeology is practiced only through a regime of regulations, and it seeks to influence that regime for its own purposes.

This reevaluation of archaeology may be discussed and debated among archaeologists, but it has not yet reached the general public. The general public stills sees archaeology as, on the one hand, a politically neutral scientific endeavor with great authority—it discovers and interprets our most ancient past, and does so free of

6. Knapp and Antoniadou 2005, p. 14.

political pressures and compromises—and on the other, as a bit of romantic derring-do, the stuff of Hollywood movies (*Indiana Jones*), of personal Web sites (for example, that of Egypt's Zahi Hawass, general director of the Supreme Council of Antiquities— zahihawass.com—with photographs of the archaeologist/politician with Bill Clinton and the caption "A Master Yarn Spinner"; with Lady Diana and the caption "Raconteur"; against a profile of the great sphinx with the caption "Guardian of Egypt's Heritage"; of him climbing into a tomb with the caption "archaeologist"; and so on), and of popular magazines, travel tours, and accurate, hand-painted reproductions of "genuine" archaeological artifacts.

The recent reevaluation of archaeology by archaeologists has stayed out of the public eye. And the arguments between U.S. art museums and archaeologists are cast as differences between rich, acquisitive, even glamorous art institutions and grant-funded scientists pursuing dispassionate research under harsh conditions. The control of archaeology and the use and misuse of its finds by nationalist governments go unremarked upon.

Despite the passage of numerous, well-intended international conventions, some of which have been ratified by dozens of nation-states, individual states—*individual national governments*—make their own self-interested decisions with regard to protecting cultural property. The Second Protocol of the Hague Convention for the Protection of Cultural Property, passed in 2004 and intended to strengthen the implementation of the earlier Convention of 1954, has not been signed on to or ratified by any of the major military powers in the world or any of the permanent members of the United Nations Security Council. And it has not prevented the dramatic and tragic destruction of so many known and unknown ancient monuments, antiquities, and archaeological sites throughout Iraq since the Coalition Forces invaded in the spring of 2003. In April of that year, the Iraq Museum in Baghdad was broken into and fifteen thousand of its objects stolen; and not only was the museum looted, the Iraqi National Library and Archives and the Ministry of Holy Endowments and Religious Affairs were set on fire and

also looted. A month later, meaning to prevent illicit trading in this stolen property, the United Nations Security Council passed Resolution 1483 banning international trade in "Iraqi cultural property and other archaeological, historical, cultural, religious, and rare scientific items illegally removed from the Iraq Museum. . . ." A year later, the U.N. Security Council passed Resolution 1546 further stressing the need for protection of Iraq's valuable archaeological sites. Neither resolution has prevented the illicit trading in antiquities and destruction of archaeological sites in Iraq. Jurisdiction over such material and activity is local, and Iraq's political affairs have been fluid, to say the least, in the three years since the invasion by the Coalition forces.

As I write, Donny George, director of the Iraq Museum, has resigned and is living in exile in Syria (and has recently been appointed to an academic position in the United States). On August 28, 2006, he was reported to have said that it was no longer possible to work at the museum since the new government officials in charge were followers of Moktada al-Sadr, the "radical Shiite cleric" who led the two uprisings against the Americans in 2004. Sadr's party holds at least thirty seats in Parliament, making him one of the most powerful, political forces in Iraq. "'I can no longer work with these people who have come in with the new ministry. They have no knowledge of archaeology, no knowledge of antiquities, nothing."[7] The Iraq State Board of Antiquities and Heritage, which traditionally reported to the Ministry of Culture, now reports to the newly formed Ministry of Tourism and Antiquities, which was created by Moktada al-Sadr as one of the ministries under his party's control. (The new minister of tourism and antiquities is a dentist, whose wife is related to Sadr.) A group of international archaeologists and their supporters wrote in protest to the Iraqi authorities, asking that the museum's collections be kept together and not split up and distributed around the country,

7. Quoted in E. Wong 2006.

that "Antiquities Guards" at archaeological sites be increased and continued to be paid, and that "cultural heritage either be independent or that it be administered by the Ministry of Culture" and "implemented by a professional, unified State Board of Antiquities and Heritage." The letter concluded by declaring that "only a strong, national, non-political State Board of Antiquities and Heritage, backed fully by the force of the state, can preserve the heritage that is left."[8]

Quite striking is the request by the letter's signatories—the letter is addressed to Iraq's president, prime minister, minister of Foreign Affairs, minister of Culture, and two members of Parliament—that "Iraq's cultural heritage be treated as part of the rich culture of the Iraqi people, to be preserved for present and future generations."[9] In the politics of cultural property, national governments have the authority to decide what is and what is not a nation's cultural property. Typically, archaeologists defend this authority against cultural property internationalists like myself by saying that we foreigners should respect a national's government claim on its cultural property. After all, it is said, the government represents the people and has the people's—*the nation's*—best interest in mind when it defines, protects, and retains cultural property for the nation. In the case of Iraq, however, clearly, a group of archaeologists do not trust the Iraqi national government to make the "correct" decision with regard to its cultural property. They conclude their letter with the admonition: "All persons who work in Antiquities should be above politics and allegiance to any party. . . . You are in positions to save the Cultural Heritage of Iraq for everyone, and we hope you do so." *Above politics and allegiance to any party?* For most of the past seventy-five years, archaeology has only been possible as a part of national politics and has always served the interest of the dominant, national political party. And in Iraq, those politics and that interest were Ba'thist.

8. http://www.archaeological.org/webinfo.php?page=10374.
9. Ibid.

During the 1970s, the Ba'thist government increased funding for archaeology by some 81 percent. (The cost of living rose only 35 percent during that same period.) And after Saddam Hussein became president in 1979, support for archaeology increased even more. Of special interest was the area's Mesopotamian past. Work began on the "reconstruction of Babylon," and in 1981, on the first anniversary of Iraq's war with Iran, celebrations were held on the ruins of Babylon under the slogan "Yesterday Nebuchadnezzar, today Saddam Hussein." So important was Ba'thist identification with ancient Mesopotamia that it wrote of the region's long history as essentially Arab. In an address to the Bureau of Information, Saddam declared: "The history of the Arab nation does not start with Islam. Rather, it reaches back into ages of remote antiquity. . . . All basic civilizations that emerged in the Arab homeland were expressions of the personality of the sons of the [Arab] nation, who emerges from one single source."[10] The Ba'thist Arabization of the Mesopotamians stressed the uniqueness and seniority of Iraq among other Arab nations and Egypt, Iraq's great rival in the region as a modern nation with an ancient past. To this end, the Iraqi historian Ahmad Susa emphasized that Mesopotamian culture, although repeatedly wiped out over the course of two thousand years, always restored itself. "This gave it," he wrote, "continuity and purity of origin, as different from the ancient Egyptian civilization which . . . ended with the end of its ancient era."[11]

The Ba'thist support of archaeology served the nationalist agenda of the state and the reification of its president, Saddam Hussein, as the next Nebuchadnezzar. Despite the recent letter writers' bald statement that "[a]ll persons who work in Antiquities should be above politics and allegiance to any party," that was never true in Iraq, or anywhere else. Archaeology can only be practiced with the approval of the state. It—and the fruit of its labors—are indelibly part of the modern nation-state's political apparatus.

10. Quoted in A. Baram 1991, pp. 11, 13.
11. Quoted in ibid., p. 106.

National politics is identity politics: Sunni, Shiite, Iraqi, Iranian, Turkish, Kurdish, Cypriot, Greek, Macedonian, Italian, American. The recent Italian government's request to the United States to impose import restrictions on a range of Italian cultural property (approved and very recently renewed) identified that property, including antiquities, as deriving "from cultures that developed autonomously in the region of present day Italy." (*Autonomously?* Through no contact with any other cultures? Despite the long presence of Greeks in Italy and despite the multiethnic, multicultural character of the Roman Empire, which at its height was in contact with most of the known world, from east Asia to Africa to Britain?)

U.S. politics is identity politics too, of course. Remember last year when Mexican Americans and Mexicans living and working in the United States began to sing our national anthem in Spanish and President Bush and others roundly criticized this as "separatist"? On May 25 of that year, 2006, the United States Senate passed an amendment to an immigration reform bill that declares English the national language of the United States. Since 1981, twenty-two U.S. states have adopted various forms of "official English legislation." And in his prime time speech before the 1992 Republican National Convention, the conservative commentator and sometimes presidential aspirant Patrick J. Buchanan declared, "There is a religious war going on in our country for the soul of America. It is a cultural war, as critical to the kind of nation we will one day be as was the Cold War itself." Nationalist politics is identity politics. It is about the formation and affirmation of the nation.

Archaeology—the work of archaeologists—is implicated in such politics. Some archaeologists—when criticizing museums for acquiring unprovenanced antiquities—argue that such antiquities should not be acquired by foreign museums because they belong to the source nations where there are presumed to have been found; that they are not only their property but, in the context of nationalist identity politics, are important to the identity and self-esteem of that nation and its nationals. If U.S. museums were to acquire them, it is said, it is only because we can afford to do so as heirs to

an imperial and colonial past. They are meaningless to us, it is argued, mere trophies of our having grown rich on the labor and natural resources of poorer nations, much as the colonizing and imperial powers did before us. Not acquiring such antiquities is, as I have heard it said more than once, a means of redressing the historical imbalance of power between first- and third-world nations. But power relations often have a long history. There are "source" nations in the first world (Italy, Greece, and increasingly, one has to say, China) and former colonizing empires in the third world (Turkey, as the heir to the Ottoman Empire, with its museums filled with antiquities from former imperial territories). There are even former imperial territories with rich remains of the empire's culture (Turkey, with its Greek and Roman remains; Egypt, Lebanon, Libya, Syria, and Tunisia with their Roman remains).

If antiquities are a modern nation's cultural property and meaningful to a nation's identity and esteem, isn't this true of provenanced as well as unprovenanced antiquities? Shouldn't museums then not only not acquire unprovenanced antiquities but also return provenanced antiquities? Are only unprovenanced antiquities important to a nation's identity? If so, why are the Greeks calling for the return of the Elgin marbles? After all, we know their provenance from the moment of their making almost 2500 years ago. (Some argue that they were removed illegally, at least those removed by Lord Elgin, but that has not and cannot be proven: there is no evidence. Anyway, if they were removed illegally, they were removed illegally from the Ottoman Empire and not Greece, since there was no Greece at the time.)

Disagreements between museums and archaeologists over the acquisition of antiquities are not about the loss of knowledge as a result of looted archaeological sites. They are about the relative importance of antiquities as such, for all that can be learned from them about the world that produced them, a world before there were modern nations and the political invention of

cultural property, a world to which, as human beings, we are all heir. Museums are dedicated to the preservation of antiquities, provenanced or unprovenanced. And encyclopedic museums are dedicated to serving as a force for understanding about the world in which we live, its ancient past and living present. This cannot be achieved by segregating antiquities as cultural property and keeping them within the borders of modern nation-states serving the agenda of modern nationalist politics. This can only be achieved by sharing the world's common cultural legacy broadly. Sadly, increasing—and increasingly strict—national ownership and export laws and international agreements are making this impossible, and we all stand to lose in the end.

An encyclopedic museum is a humanist enterprise and part of the humanist critique of politicized culture. Edward Said wrote of this critique in the preface to the last edition of his book *Orientalism,* just months before he died. He said it should be used "to open up the fields of struggle, to introduce a longer sequence of thought and analysis to replace the short bursts of polemical, thought-stopping fury that so imprison us in labels and antagonistic debate whose goal is a belligerent collective identity rather than an understanding and intellectual exchange . . . humanism is sustained by a sense of community with other interpreters and other societies and periods: strictly speaking, therefore, there is no such thing as an isolated humanist."[12]

Said was committed to opening up our understanding of the world. A Christian Palestinian raised in Egypt and educated in the United States, he wrote powerfully of literature, music, culture, and politics. Among his final, published words were these: "Rather than the manufactured clash of civilizations, we need to concentrate on the slow working together of cultures that overlap, borrow from each other, and live together in far more interesting ways than any abridged or inauthentic mode of understanding can allow. But for that kind of wider perception we need time and patient and

12. E. W. Said 2003, p. xvii.

skeptical inquiry, supported by faith in communities of interpretation that are difficult to sustain in a world demanding instant action and reaction."[13] We should remember this when we consider the purpose of encyclopedic museums and why they strive to collect representative examples of the world's common artistic legacy, both those of recent and those of ancient manufacture, even if the latter are unprovenanced.

Some argue that encyclopedic museums are a Western phenomenon and that praise for and justification of them are only ways of legitimizing the West's history of colonial, imperial, economic, and political dominance over the rest of the world. The idea of the encyclopedic museum is not the exclusive property of the West, even if most encyclopedic museums are in the West. And if it is a good idea to have representative examples of all the world's cultures under one roof for curious people to see, to think about, to better understand and appreciate—to become more sensitive to the cultures of others, to the Other, to the expansive, rich, fecund diversity of the world's many cultures that over millennia have overlapped and influenced each other, such that each has a claim on the other—it is *a good idea, period.* That encyclopedic museums are primarily in one part of the world and not others is not an argument against them. It is an argument for the development of encyclopedic museums everywhere.

In my mind, the competing questions before us are how to preserve archaeological sites and promote the international movement of works of art, antiquities and otherwise. Nationalist retentionist cultural property laws discourage and often prevent the latter in the service of the former. How can we square nationalist cultural property laws with what we know of the history of ancient objects? As Kwame Anthony Appiah has written of Nok sculptures, which, although made two thousand years ago, are

13. Ibid., p. xxii.

claimed by the modern state of Nigeria (which itself is less than one hundred years old) as part of its national patrimony: "We don't know whether Nok sculptures were commissioned by kings or commoners; we don't know whether the people who made them and the people who paid for them thought of them as belonging to the kingdom, to a man, to a lineage, to the gods. One thing we know for sure, however, is that they didn't make them for Nigeria."[14]

I conclude with a modest proposal: *Why don't archaeologists and art museums join forces? Why don't archaeologists threaten not to excavate in foreign countries—and thus not allow archaeology to serve nationalist policies—and art museums threaten to continue to acquire any and all unprovenanced antiquities until nations render archaeological sites and antiquities up to international control, free of national political interference?*

Why don't we—art museums and archaeologists and their sympathizers—work together to counter the nationalist basis of national laws and international conventions and agreements and promote a principle of shared stewardship of our common heritage? John Henry Merryman has already articulated a framework for reconsidering national and international cultural property laws. His "triad of regulatory imperatives" comprises preservation, knowledge, and access. Antiquities should be distributed around the world to better ensure their preservation, broaden our knowledge of them, and increase the world's access to them. Surely these are better principles on which to proceed than the nationalist ones enshrined in national laws and UNESCO's conventions.

The argument between art museums and archaeologists and their sympathizers is not over whether antiquities and archaeological sites should be preserved. It is over how best to preserve them and increase our knowledge of and public access to them. By increasing and strengthening nationalist retentionist cultural property laws and international conventions? By emboldening nation-states and encouraging them to join forces to reclaim *their* self-

14. K. A. Appiah 2006, p. 119.

proclaimed cultural property—Italy with Greece, Egypt with Italy and Greece, China with Peru, and more? Nation-states are feeling more confident now than ever before. And the world's ancient artistic legacy is being held hostage to the nationalist ambitions of nation-state governments. This, I am arguing is what we should be discussing today. It is of the greatest importance in the age of ever-increasing sectarian violence and nationalist politics.

As the Indian-born, Bengali, Nobel Prize-winning economist Amartya Sen has written in his recent book, *Identity and Violence*: "The hope of harmony in the contemporary world lies to a great extent in a clearer understanding of the pluralities of human identity, and in the appreciation that they cut across each other and work against a sharp separation along one single hardened line of impenetrable division."[15]

Bibliography

Appiah, K. A. 2006. *Cosmopolitanism: Ethics in a World of Strangers*. New York.

Atkinson, J. A., I. Banks, and J. O'Sullivan. 1996. *Nationalism and Archaeology*. Glasgow.

Baram, A. 1991. *Culture, History and Ideology in the Formation of Ba'thist Iraq, 1968–89*. Houndmills, Basingtoke, Hampshire.

Bernhardsson, M. T. 2005. *Reclaiming a Plundered Past: Archaeology and Nation Building in Modern Iraq*. Austin.

Díaz-Andreu, M., and T. Chapman, eds. 1996. *Nationalism and Archaeology in Europe*. San Francisco.

Gellner, E. 1983. *Nations and Nationalism*. Ithaca, NY.

Knapp, A. Bernard, and Sophia Antoniadou. "Archaeology, Politics and the Cultural Heritage of Cyprus." In *Archaeology under Fire: Nationalism, Politics, and Heritage in the Eastern Mediterranean and Middle East*, ed. L. Meskell, pp. 13–43. London.

Kohl, P. L., and C. Fawcett, eds. 1995. *Nationalism, Politics, and the Practice of Archaeology*. Cambridge.

15. A. Sen 2006, p. xiv.

Lewis, B. 1961. *The Emergence of Modern Turkey.* 2nd edition. Oxford.

————. 1998. *The Multiple Identities of the Middle East.* New York.

Merryman, J. H. 1986. "Two Ways of Thinking About Cultural Property." *American Journal of International Law* 80.4, October, pp. 837–38.

————. 1995a. "A Licit International Trade in Cultural Objects." *International Journal of Cultural Property* 1, pp. 13–60.

————. 1995b. "The Nation and the Object." *International Journal of Cultural Property* 4, pp. 61–76.

————. 2005. "Cultural Property Internationalism." *International Journal of Cultural Property* 12, pp. 11–39.

Meskell, L., ed. 2005. *Archaeology under Fire: Nationalism, Politics, and Heritage in the Eastern Mediterranean and Middle East.* London.

Said, E. W. 2003. *Orientalism.* Reprinted with a new preface. London.

Sen, A. 2006. *Identity and Violence: The Illusion of Destiny.* New York.

Shadid, A. 2006. "Lebanon, My Lebanon." *The Washington Post,* April 16, B1.

Shanks, M., and C. Tilley. 1987. *Social Theory and Archaeology.* Cambridge.

Silberman, N. A. 1990. *Between Past and Present: Archaeology and Nationalism in the Modern Middle East.* New York.

————. 1997. "Nationalism and Archaeology." In *The Oxford Encyclopedia of Archaeology in the Near East,* ed. E. M. Meyers, vol. 4, pp. 103–12. Oxford.

Smith, A. D. 1984. "Alternative Archaeologies: Nationalist, Colonialist, Imperialist." *Man* 19, pp. 355–70.

————. 1991. *National Identity.* Reno, NV.

Wong, E. 2006. "Director of Baghdad Museum Resigns, Citing Political Threat." *New York Times,* August 28, p. 6.

Response to James Cuno

Charles Rosenberg

IN THE VERY LIMITED TIME ALLOTTED FOR MY OWN
comments, I would like to address two points.

First, Mr. Cuno informs us that the general public has been un-
aware that a symbiotic relationship exists between archaeologists
and nation-states. This ignorance, he says, has led to archeologists
exerting undue influence in the public debate over the circulation
of unprovenanced objects and the protection of cultural heritage.
As I understand Mr. Cuno's argument, the relationship between ar-
chaeologists and nations has taken two forms:

First, governments have exercised control over the practice of
archaeology within their borders by granting permits and distribut-
ing public monies. In this manner, some governments have privi-
leged national and/or sympathetic archaeologists by limiting access
to sites for some applicants, and rewarding others who will generate
"the right kind of conclusions."

Second, some governments have exploited the information
generated by archaeologists for political purposes, using it to fash-
ion history and define cultural heritage in ways that are suited to
their own ideological and political ends.

There is probably no one in this room who would deny that
abuses of power exist. However, what Mr. Cuno perceives as sinister
by-products of nationalism may equally be viewed as the result of

varying levels of success at pragmatic regulation. It seems to me that *some* sort of regulation is inevitable; one could hardly sanction indiscriminate excavation of archaeological sites. Some mechanism has to be applied to guarantee the expertise and professionalism of those who propose to carry out this kind of work—hence, the permit. Just as in the housing industry, these permits are sometimes the result of cronyism or baksheesh. Nonetheless, overall, they serve a purpose in terms of oversight and information. Because there are abuses of this regulatory mechanism does not mean that those who are subject to it are necessarily corrupt. Similarly, the public purse is not bottomless. In the best of all possible worlds, these funds would be distributed in an equitable fashion, in the service of the public interest—however that may be defined. We know that this is not always the case, even in the most open of societies. One need only look at the recent history of the National Endowment for the Arts or the National Endowment for the Humanities for evidence of this. However, the fact that the mechanisms for funding exhibitions, artistic creation, and research are imperfect does not mean that the practices and products of museologists, archaeologists, artists, or scientists are tainted. It does not follow that those who pursue these professions are incapable of separating politics from practice or of speaking as professionals, rather than as representatives of governmental agencies or foundations.

In respect to the second category of abuses, the manipulation of archaeological information for political ends, this exploitation of archaeological discoveries and analysis is not the fault of those who have uncovered the past. One cannot blame the victim for the crime. The Palavi shah's decision to exploit Cyrus the Great for his own political ends was not made by those who excavated Persepolis. Certainly, Mr. Cuno would not wish us to conclude that because museums have historically been exploited by some corporations and governments for their own ends, all of these institutions and those who represent and work for them act and speak only in the service of the nation or some capitalistic enterprise.

The second point which I would like to consider is a clarification of Mr. Cuno's framing of *why* archaeologists are in favor of restricting museums' acquisition of unprovenanced antiquities. In the beginning of his paper, Mr. Cuno tied this argument to the question of the legality or illegality of the contemporary trade in antiquities, which, in turn, led him to questions of how cultural identity is formed, how cultural property should be defined, and whether national rights of ownership can be legitimately derived from these definitions. These issues have important ramifications for the fate of artifacts already in circulation and the legal consequences for those who have engaged in looting. However, these are not the concerns which drive the archaeologist's critique of museums' overt or tacit participation in the market in unprovenanced antiquities. From the archaeologist's point of view, the crucial question is not who owns things but how one can ensure that the kind of information which can *only* be extracted from objects in context is not lost. The archaeologist's desire for transparency of provenance in the licit marketplace is motivated by a desire to stop looting in order to protect find-site specific knowledge. Two objections have traditionally been raised to the imposition of rigid provenance requirements as a means of reducing this sort of destructive activity. First, it has been noted that unprovenanced antiquities which appear on the market have already lost their archaeological value and that therefore, in regard to these objects, the only concerns should be preservation and public access. Second, it has been suggested that even if reputable dealers and museums trafficked only in provenanced objects, looting would still continue, with significant pieces simply migrating out of the public eye and into an expanded illegal marketplace. In respect to the first objection, it is unfortunately true that we cannot restore knowledge which has already been lost. But though this may be an argument for not applying provenance standards retrospectively, it is not one for not instituting them now, as a deterrent to future abuse. If the Association of Art Museum Directors and dealers were willing to agree that no archaeological artifact

without an unbroken paper trail that begins in 1970, as recommended by the Archaeological Institute of America, or even *tomorrow*, would be considered for sale or acquisition, then looting would immediately become a less lucrative proposition, because these conduits and buyers would be eliminated from the market.

Which brings me to the second objection, the existence of an illegal trade in antiquities which will still support looting. This objection can be answered in two ways. First, realistically there is a finite market for "museum quality" antiquities. Removing the major *licit* mechanisms by which illegally excavated objects currently circulate in the marketplace and all of the public and licit sources of demand will certainly reduce the economic incentives for looting by shrinking the market. Second, simply because the adoption of these standards of documentation will not entirely eliminate abuses, does not mean that there is not a larger moral imperative to act in such a way as to *not* reward those who engage in these abusive practices.

Mr. Cuno asserts that disagreements between archaeologists and museums over the acquisition of antiquities is not about the loss of knowledge as a result of looted archaeological sites, but that is precisely what it is about. Is there knowledge to be gained even from unprovenanced objects? Of course. No one disputes the value of the kinds of provocative juxtapositions which can only be made in the context of a museum. But the fact that artifacts can be fascinating and informative in and of themselves does not absolve those who collect and display them from doing their utmost to assure that future acquisitions are not allowed to be shorn of the additional knowledge which can only be derived from their more complex and comprehensive web of context, and this is why archaeologists have argued so strongly for the need for provenance.

Dealing with Looted Antiquities

Existing Collections and the Market

Malcolm Bell III

THE PAST SEVERAL YEARS HAVE DRAMATIZED AS never before the need to protect artistic monuments and archaeological sites from intentionally destructive acts. The bombing of the Bamiyan Buddhas in Afghanistan, the looting of the Archaeological Museum in Baghdad and of sites throughout Iraq, the prosecution in Rome of prominent figures from the world of museums and the art market, and the recent repatriation of pillaged works to Italy by U.S. museums have all demonstrated to an international public the continuing risks run by sites and monuments, and the damage done to them by religious intolerance or by the commercial market in antiquities. Such acts and events have had the more positive consequence of also making known much more widely the fragility and interconnectedness of the remarkable remains of human culture.

While the sort of intentional destruction carried out by the Taliban is fortunately rare, the pillaging of archaeological sites is a much more widespread phenomenon. Speaking as an archaeologist and art historian, I believe that our response to the problem of pillaging should be simple and direct. First, antiquities from the soil should always be recovered through scientific excavation, never by

pillaging. Second, in order to protect ancient sites from exploitation, the market in unprovenanced antiquities should be eliminated to as great an extent as possible. Given the extensive pillaging now taking place from Iraq to Afghanistan, such principles may seem idealistic and hardly capable of realization. Yet recent developments have shown that suppression of the trade in illegally obtained and exported antiquities has increasing endorsement from a worldwide public: that, in effect, these are not just the notions of a radical minority of archaeologists, as has been claimed by U.S. museum administrators, but a widely shared reasoned defense of the common heritage of humanity.

The objective of largely eliminating the market can certainly be realized. Recent developments show that it is already underway in the Mediterranean area, a rich traditional source for collectors and museums. The Italian police reported early in 2007 the recovery of remarkable pillaged Roman reliefs of gladiators that evidently could not find buyers; and in their enabling legislation for the UNESCO Convention of 1970 the United States and Switzerland, once major importers of looted Greek vases, have recognized the Italian claim to such works if they lack legitimate provenance.

For the market to be even further diminished, the traditional buyers of antiquities must acknowledge their role in the chain of cause and effect, refusing to acquire unprovenanced objects. All museums and individuals collecting antiquities should adopt a deontological code that specifically addresses the central problem of collecting: namely, the direct relationship of the market to pillaging. The recent statement by the president of the International Council of Museums (ICOM) is a forthright recognition of this reality: "it is clear that the curbing of illicit trafficking is directly dependent on the ethical principles and sanctions against the acquisition of unprovenanced material applied by museums" (Alissandra Cummins, December 2006). We should also note that under section 501(c)(3) of the Internal Revenue Service Code museums are granted tax-exempt status because of their scientific and educational objectives; when these aims are contradicted by participation in the destructive

illegal market, the justification for tax-exemption becomes highly questionable.

While collectors and museums should put restrictions on acquisitions, gifts, and loans, a new code will not solve all problems. One question concerns what should be done with regard to important unprovenanced antiquities acquired in recent years in violation of the new policies; and others concern unprovenanced works of major and minor importance now on the market, or that may become available for purchase in the future. Before considering these questions, it will be useful to state the chief reasons why museums and collectors should separate themselves from the illegal market. Though they may be familiar, they will always bear repeating.

The losses caused by pillaging are of several kinds. Two are reciprocal. On the one hand, the ancient works are removed from the sites and stripped of all the information that real archaeological provenance would provide, information that would illuminate their history, function, and ancient ownership. On the other, the sites lose the works themselves, and the light that they in turn would shed on the character of local culture, life, history. A comparison will illustrate these points. The marble sculpture of a charioteer (fig. 1) found in 1979 in legitimate Italian excavations on the island of Motya in western Sicily can be compared to the extraordinary cult statue of a goddess (fig. 2) acquired by the J. Paul Getty Museum in 1988, sometimes attributed to Morgantina though as yet without solid evidence; or to the bronze Apollo purchased in 2004 by the Cleveland Museum of Art (photographs available on the museum's website), the history of ownership of which has not been satisfactorily revealed. Motya was the chief military base of Carthage in western Sicily, where booty was taken from several Greek cities captured by Carthaginian armies in the last decade of the fifth century BCE. From the odes of the Greek poet Pindar we know that the tyrants of Sicilian cities like Gela and Akragas had earlier won chariot victories in the games at Olympia and Delphi, and it is likely that the remarkable Greek sculpture from Motya represents a victorious Sicilian charioteer. He is thus likely to have come to Motya as war

Figure 1. Marble sculpture of a Greek charioteer, from Motya in Sicily, ca. 475 BCE. Museo Whitaker, Motya, Sicily. Courtesy of M. Bell; photograph M. Bell.

Figure 2. Limestone and marble cult statue of a goddess, provenance uncertain, ca. 425–400 BCE. Courtesy of the J. Paul Getty Museum; museum photograph.

booty. The work's surprising discovery on a Carthaginian site is thus an essential key that illuminates both Sicilian history and the history of Greek art. Without the knowledge provided by excavation the charioteer would be a beautiful but enigmatic museum piece. I can add that he has remained in the local museum on the island of Motya, where he attracts increasing numbers of visitors.

The extraordinary bronze figure in Cleveland presents a contrasting case. It is the finest known version of the lizard-slaying Apollo created by the great Athenian sculptor Praxiteles—very close indeed to the original, that much can be said. Like the Getty goddess, this is the sort of work that cries out for knowledge of the history of its ownership in antiquity, of where it stood and what fortunate population admired it, but here the circumstances of its acquisition appear to deny us that information. As Simon Mackenzie has recently shown in his revealing book *Going, Going, Gone: Regulating the Market in Illicit Antiquities* (Institute of Art and Law, Leicester 2005), information about provenance is regularly suppressed by the market in order to prevent claims on the purchaser by the country of origin. The provision of a false provenance is not occasional but typical. If the original findspot of the remarkable work in Cleveland can eventually be identified, as one hopes it will be, it seems likely that there will be such claims. While such purchases should be avoided for ethical and intellectual reasons, they also create unwanted situations of public embarrassment and financial risk.

Another category of loss is represented by the grievous physical damage to the sites caused by pillaging, which should be acknowledged by everyone concerned with the preservation of the records of human history. As you are all aware, burials with their accompanying grave goods are frequent targets of illegal excavators who invariably discard the bones or ashes of the dead. The pillaging of tombs also destroys the evidence of human intentions represented in the selection and function of grave goods, as the associated objects from individual burials are dispersed without record. And the material structure of the tomb, which may have architectural,

sculptural, or pictorial features, is often irreparably damaged. (The Native American Graves Protection and Repatriation Act of 1990, or NAGPRA, protects the recovered remains of native Americans, just as the Archaeological Resources Protection Act, or ARPA, protects burials; we may well ask if the principles of respect for the local dead exemplified by such legislation do not have a more general global relevance.)

As for the ancient settlements, the indiscriminate search for metal in the form of coins, jewelry, or vessels causes the destruction of walls and floors of houses, as well as the dissolution of the assemblages of associated materials that may once have lain upon the floors. The often-repeated claim that coins and metalwork are usually found casually in the countryside is simply untrue, as actual acquaintance with the pillaged sites clearly demonstrates. This is a conveniently easy claim to make, of course, when the real findspot is unknown, obliterated by the illegality of pillaging. The potentially valuable historical, social, and cultural evidence of such original contexts is irretrievably lost. The unhappy scholar who has tried to study a pillaged site quickly perceives the extent of the damage, which can be enormous. By definition archaeological sites are ruins, sometimes because of human agency, sometimes as victims of natural disaster. A pillaged site is doubly devastated, often to the point of becoming incomprehensible to scientific inquiry. The human tragedy of ancient destruction and abandonment is compounded by the havoc brought about by modern market forces. I would not wish the experience of excavating a pillaged site on anyone, not even on the coin collectors and curators who purchase the stolen objects.

The pillaged works are also lost to the source countries. Many archaeological sites exist today as national monuments accompanied by museums, and for local populations the sites and associated museums have great potential value of both educational and economic nature. The pillaged works are lost to such local populations and institutions and to their visitors. We may want to ask if the claims of the foreign museums and collectors are stronger than those of the local communities.

Let me return to the problem of eliminating the market in un-provenanced materials. This can be effectively aided from above by legislation and regulation, as exemplified in this country by the cultural property accords with source countries set up by the Cultural Property Implementation Act (CPIA) of 1983, which implemented some of the clauses of the UNESCO Convention of 1970. Eleven such accords are now in effect. Yet the problem of the market can and should also be confronted from below by collecting individuals, institutions, and dealers. Just a year ago the Archaeological Institute of America proposed that an acceptable museum acquisitions policy for antiquities should include several basic points (the full text is available at the AIA website, www.archaeological.org). 1) The policy should be a written one, made known widely to museum administrators and trustees as well as to the general public by means of the museum's website. 2) The policy should clearly reject purchase of recently pillaged objects. 3) In order to define what is mean by recent pillaging, the policy should specify a date before which a work must have become known if it is to be considered for purchase. 4) Due diligence should be exercised in all acquisitions of ancient works. While the aim is to separate the museum as much as possible from active looting, the specified date before which a work must be documented is for the museum to determine. It could be that of the relevant legislation in the source countries regarding the ownership and circulation of antiquities or it could be the date of the adoption of the UNESCO Convention (14 November 1970); or—and this is my suggestion, not the AIA's—it could be a rolling date sufficiently far back in time to assure that the museum does not participate in the chain of cause and effect that results in pillaging; a period of at least thirty years would seem reasonable. The British Museum and the J. Paul Getty Museum have both recently adopted the date of 1970.

There remains the matter of unprovenanced antiquities acquired relatively recently under more permissive policies, works that could not be considered for purchase after a museum has adopted a properly tough acquisitions policy. The Italians have pre-

sented documentary evidence for the illegal excavation and export of a limited number of recently acquired unprovenanced works to the Metropolitan Museum of Art, the Museum of Fine Arts in Boston, and other U.S. collections, and a series of repatriations is now underway. Notable examples in New York are the Athenian red-figure krater painted by Euphronios, which will return to Rome, and the treasure of Hellenistic silver from Morgantina, which will go back eventually to Sicily. As I am sure you are aware, the substantial legal and administrative expenses for museums that have resulted from such unwise acquisitions have been accompanied by other less tangible kinds of damage to personal and institutional reputations.

The issue is, however, much larger than the question of a few repatriations, for since 1970 (a date after which it was reasonable and correct to withdraw from the illegal trade) these and many other museums have made numerous purchases of unprovenanced materials. This is the period of the sacking of cemeteries in the Italian region of Apulia, a disaster stimulated by the worldwide demand for Apulian red-figure vases. Important examples of Apulian pottery can be seen in prominent European and U.S. museums. The sad history of this episode in collection-building has been documented by Ricardo Elia of Boston University ("Analysis of the Looting, Selling and Collecting of Apulian Red-figure Vases: A Quantitative Approach," in N. Brodie, J. Doole, and C. Renfrew, editors, *Trade in Illicit Antiquities: The Destruction of the World's Archaeological Heritage*, Cambridge, 2001) and by the European scholars Daniel Graepler and Marina Mazzei (in *Fundort unbekannt, Raubgrabungen zertstören das archäologsiche Erbe*, Munich, 1993). We may also note that the unprovenanced Euphronios krater, the Morgantina silver, the Getty goddess, and the Cleveland Apollo were all purchased by U.S. museums after 1970.

Museums possessing such works should now seriously consider notifying the countries of origin of the presence in their collections of major, recently acquired unprovenanced antiquities. To aid in the identification of their probable origins in modern states,

the U.S. cultural property accords under the CPIA have established useful lists of categories deriving from specific source countries, and these can be supplemented by the Red Lists of antiquities at risk prepared by ICOM. The preparation by U.S. museums of lists of major unprovenanced antiquities acquired after 1970 should be seen as in some way analogous to the careful inventories the same museums have conducted in order to identify works of art illegally taken from European Jews in the 1930s and 1940s. While the latter crimes against living individuals are more severe and immediate, and the legal and moral issues extremely clear, the destruction of the human past in order to satisfy the perceived needs of collectors and museums cannot be said to be morally defensible.

The aim of notification of the source countries would be to bring closure to the fraught involvement of museums and collectors with the illegal market, and to resolve possible eventual conflicts. It will be necessary for the source countries to devise responses to individual cases, which could range from repatriation to the redefinition of an unprovenanced acquisition as a long-term loan, or to the recognition of actual ownership by the foreign institution. Mediation, as discussed by ICOM in 2006, seems likely to play a role in possible disputes. Recent events in Italy have demonstrated that a combination of documentary evidence, legal pressure, and moral suasion can be effective in resolving individual cases. What is called for now is a general survey of U.S. collections, based on the recognition that recently acquired unprovenanced works are almost certainly produced by recent pillaging.

Rather than criticizing the laws and regulations of the source countries, as prominent American museum administrators have done, I believe that it is both wiser and more practical to accept and endorse the position of article 13 of the UNESCO Convention of 1970, which states that parties to the Convention (among which the United States is one) "recognize the indefeasible right of each State Party . . . to classify and declare certain cultural property as inalienable which should therefore *ipso facto* not be exported, and to fa-

cilitate recovery of such property by the State concerned in cases where it has been exported." State ownership of subsoil antiquities has been claimed for serious reasons by almost all archaeologically rich countries, and the legitimacy of such claims has been acknowledged in U.S. courts. An assault on widely accepted international legal principles is quixotic and little likely to succeed. Recognizing the right and responsibility of source countries to protect their archaeological heritage, we should rather in a cooperative spirit encourage them to further the circulation of travelling exhibitions and to make possible long-term loans of artifacts and works of art. Innovative policies are also needed both here and in the source countries to resolve the status of recently pillaged art in U.S. museums, which is, let it be remembered, defined legally as stolen property. The liberalization of loan policies has already taken place in Italy, which in the past several years has shown itself to be both a vigorous defender of its stewardship of the archaeological past and a knowledgeable participant in the international community of museums. Greece is proceeding along the same path. What is called for now on our part is a comparable response characterized by honesty, transparency, and respect for law.

Bibliography

Policies

Archaeological Institute of America, AIA Principles for Museum Acquisitions of Antiquities (www.archaeological.org).
British Museum, British Museum Policy on Acquisitions (www.thebritish museum.ac.uk, governance: acquisitions).
International Council of Museums (ICOM), Code of Ethics 2006 (www.icom.org).
J. Paul Getty Museum, Acquisition Policy 2006 (www.getty.edu/about/governance/policies.html).

Publications

Bell, M., III. 2002. "Italian Antiquities in America." *Art, Antiquity, and the Law 7*, pp. 195–205.

Brodie, N., J. Doole, and C. Renfrew, eds. 2001. *Trade in Illicit Antiquities: The Destruction of the World's Archaeological Heritage.* Cambridge.

Gerstenblith, P. 2004. *Art, Cultural Heritage, and the Law: Cases and Materials.* Durham, NC.

Graepler, D., and M. Mazzei. 1993. *Fundort unbekannt, Raubgrabungen zertstören das archäologische Erbe.* Munich.

Mackenzie, S. 2005. *Going, Going, Gone: Regulating the Market in Illicit Antiquities.* Institute of Art and Law, Leicester.

Stille, A. 2002. *The Future of the Past.* New York.

Watson, P. 1997. *Sotheby's: The Inside Story.* New York.

Watson, P., and C. Todeschini. 2006. *The Medici Conspiracy: The Illicit Journey of Looted Antiquities.* New York.

Response to Malcolm Bell

Dennis P. Doordan

I AM THE CHAIRPERSON OF THE DEPARTMENT OF ART, Art History, and Design at the University of Notre Dame, and before I begin my response to Professor Malcolm Bell's paper I want to say a few words as the departmental chair. I thank all the parties here at Notre Dame that worked together to make this symposium happen. Timely and important intellectual events such as this symposium remind all of us what can be accomplished when various units of the university such as the Snite Museum of Art and the Department of Art, Art History and Design work together to promote dialogue about practices and explore issues whose significance extends far beyond the campus.

I am also one of the editors of the journal *Design Issues,* and I want to call to the attention of this audience an article in a recent issue of the journal. Gökhan Ersan, a young Turkish scholar, published a piece titled "Secularism, Islamism, Emblemata: The Visual Discourse of Progress in Turkey" (*Design Issues* 23, no. 2 [2007], pp. 55–65). In it Ersan reviews the controversy over efforts to redesign the municipal emblem of Ankara, Turkey. In the early 1930s republican officials adopted a new emblem for the city based upon an ancient Anatolian artifact: the sun disk of the Hatti. In recent years Islamist politicians attacked this emblem as pagan in origin and amidst great controversy replaced it with a new one based on

the distinctive profile of an Ottoman mosque. I cite this article as a reminder that the sources and elements of national identities in the modern era are hotly contested. As Ersan's essay reminds us, historical signs and ancient artifacts serve as potent political symbols as well as objects of aesthetic interest. Any conversation about the fate of ancient artifacts must acknowledge their contemporary political role as well as their ultimate museological fate.

A symposium such as this offers an opportunity to examine the conceptual categories and terms we employ when we carry on a conversation about the fate of ancient artifacts. The term I wish to examine is *country of origin*. Professor Bell calls upon museums possessing major unprovenanced works acquired after 1970 to notify the country of origin of the presence of such works in their collections. Country of origin is a critical concept for any discussion of the repatriation of artifacts acquired improperly. But one must ask the question: repatriate to where and to whom? What is the relationship between the boundaries of modern nation-states and the ancient civilization that produced the artifacts in question? What happens, for example, when we substitute the term *culture of origin* for country of origin? What claim can be made by people who can demonstrate a lineal cultural relationship to these artifacts but in fact do not have a claim to be part of the political entity designated today as the source country? And perhaps most troublingly, what responsibilities do the current owners of such artifacts have to protect them from political regimes that for religious or ideological reasons may not value them? In the article I cited above, the author argues that the ancient pre-Islamic origins of the Hatti sun disk (one of the attributes that made it appealing to the post-Ottoman republican political leadership of Ankara) rendered it unacceptable to contemporary Islamist municipal leaders.

When we move from the discussion of symbols to the fate of artifacts the issues of stewardship must be confronted. Earlier in this symposium James Cuno spoke about the claim of nations to property they define as important to their national identity. What of nations, however, that do not believe the property in question is

important or valuable and feel under no imperative to protect such property? Professor Bell reminds us of the loss to science, history, and culture that occurs when sites are pillaged. The fate of the Buddhas of Bamyan reminds us that the loss of cultural heritage due to wanton acts of destruction is not confined to the shadowy world of grave robbers and unscrupulous dealers. The Buddhas of Bamyan were two monumental statues of standing Buddhas carved into the side of a cliff in the Bamyan valley of central Afghanistan. Built during the sixth century, the statues represented the classic blended style of Greco-Buddhist art. They were destroyed by the Taliban in 2001. Any discussion of repatriation must address not only questions of national ownership but international stewardship. It would be irresponsible to return objects to their country of origin in situations in which it is not the ability but the commitment to protecting them that is in question.

The Acquisition and Exhibition of Classical Antiquities

The Legal Perspective

Patty Gerstenblith

THE LEGAL PERSPECTIVE ON THE ACQUISITION AND exhibition of classical antiquities implicates several aspects of integrated national and international legal doctrine, yet is fairly straightforward. On the other hand, a series of events over the past decade and more illustrate a persistent refusal of some in the museum world to accept the fundamental law. In so doing, they attempt to set themselves above the law based on the presumption that their view of the museum's educational mission allows them to act in an extra-legal manner. This attitude not only has caused American museums to lose artifacts and thereby waste publicly subsidized funds, but has also allowed them to subsidize, even if only indirectly, the destruction of knowledge in fulfillment of their acquisitorial desires. Other papers in this publication explain in more detail the negative consequences for the public and the damage done to our ability to reconstruct and understand the past through the looting of archaeological sites. I will begin by setting out some of the basic principles of international and domestic U.S. law that

intersect with the market in antiquities and then comment further on whether the practices of some museums in the United States accord with this legal regime.

The Legal Framework

International Law and National Implementation:
The 1970 UNESCO Convention

The 1970 UNESCO Convention on the Means of Prohibiting and Preventing the Illicit Import, Export and Transfer of Ownership of Cultural Property was written in response to the growth of the international art market in the years of prosperity following World War II and the market's contribution to the theft and illegal export of cultural property, the looting of archaeological sites, and the dismemberment of cultural monuments. One hundred and eleven nations are now party to the UNESCO Convention. The United States was one of the first market nations to ratify it, but today most of the significant market nations are parties. The United States' implementing legislation, the Convention on Cultural Property Implementation Act (CPIA), was not passed until 1982, and it implements only two sections of the convention, Article 7(b) and Article 9.[1]

Article 7(b) pertains only to cultural property that had been inventoried in the collection of a museum or other public religious or secular institution. The CPIA prohibits the import into the United States of any stolen cultural property that had been documented as part of the inventory of a museum or other secular or religious

1. 19 U.S.C. §§ 2601-13. *Editor's note* for nonlawyers: U.S.C. stands for United States Code. The preceding number is the particular "title," by which subject matter is organized (for instance, all of Title 19 deals with customs). Numbers and letters following the symbols identify the particular statutory section.

public institution located in another nation that is a party to the convention.[2] In order to seize and forfeit cultural property under this provision, all the U.S. government must demonstrate is that the property was stolen after both the country in which the institution is located and the United States became parties to the convention.

Article 9 calls on States Parties to provide a mechanism by which other nations that are party to the convention can seek assistance to prevent jeopardy to their cultural patrimony through pillage of archaeological or ethnological objects. The CPIA implementation of Article 9 is premised on U.S. recognition of another State Party's export controls and requires that a State Party submit a request to the United States to impose import restrictions on illegally exported archaeological or ethnological objects. The U.S. president can apply restrictions on designated categories of archaeological and ethnological objects pursuant to either a bilateral agreement, which is negotiated between the United States and the other country, or an emergency action, in cases of crisis threats to the other country's cultural patrimony.[3]

For the United States to enter into a bilateral agreement, four statutory criteria must be satisfied: first, that the other country's cultural patrimony is in jeopardy from pillage of archaeological or ethnological objects; second, that the other country has taken internal steps consistent with the convention to protect its archaeological sites (that is, the other country has undertaken education and law enforcement efforts to reduce pillage); third, that the United States' action will be taken as part of a multilateral effort; fourth, that imposing import restrictions would further the public interest in international exchange of cultural materials for scientific and educational purposes. There is also an exception to the third criterion if the U.S. import controls would be of substantial benefit in preventing pillage, even if other countries with a significant import trade in the same materials do not undertake similar actions.

2. 19 U.S.C. § 2607.
3. 19 U.S.C. §§ 2602-03.

The emergency provisions of the CPIA permit the U.S. president to impose import restrictions unilaterally. The criteria for an emergency action focus only on whether there is a crisis situation in the requesting nation that threatens its cultural patrimony. However, the other nation cannot bring a request for import restrictions under the emergency action provisions; rather, it must first request a bilateral agreement and undergo the same, lengthy process to determine whether the criteria for both a bilateral agreement and emergency action are satisfied.

The request for a bilateral agreement is reviewed by the Cultural Property Advisory Committee, which has eleven members representing the interests of the public, museums, archaeology and anthropology, and the market. The committee makes a recommendation to the president or his delegated decision maker who then determines whether an agreement or emergency action is justified. An agreement can last for a maximum of five years but can be renewed an indefinite number of times. An emergency action can last for up to five years and can be renewed only once for a maximum of three additional years. The United States currently has eleven such agreements.[4]

The CPIA process imposes an additional burden on nations that have already joined the UNESCO Convention and, until Switzerland's ratification, the United States was the only nation that required this additional process for other States Parties to gain the protections that are granted by the convention. Because restrictions are only prospective in nature, the length of time that it takes to complete the CPIA process, from the time a country makes a request to the time that the import restrictions are imposed, means that there are months, sometimes years, in which such materials may be smuggled out of a requesting nation, and the subsequent import of those materials into the United States will not be pro-

4. The list of countries, the designated list of archaeological and ethnological materials, and an image database of artifacts subject to import restriction may be found at http://www.exchanges.state.gov/culprop.

hibited. Perhaps the most severe limitation of the CPIA is that the import restrictions endure for only a limited time. The fact that the agreements must be renewed every five years means that the incentive to loot archaeological artifacts is not effectively removed. Looters, middlemen, and dealers may be willing to hold looted materials for five years, in the hope or expectation that the bilateral agreement at some point will not be renewed and these objects will then become salable in the United States.

In 2002 and 2003, particularly in the aftermath of the war in Iraq, several new market nations ratified the UNESCO Convention, including the United Kingdom, Japan, Denmark, and Switzerland, while Germany has passed its implementing legislation and will deposit its instrument of ratification by the end of 2007. As part of its ratification, the British Parliament enacted a new Dealing in Cultural Objects (Offences) Act 2003,[5] which creates a new criminal offense for dealing in "tainted cultural objects." The statute defines a "tainted object" under the following circumstances: "A cultural object is tainted if, after the commencement of this Act (a) a person removes the object in a case falling within subsection (4) or he excavates the object, and (b) the removal or excavation constitutes an offence." Subsection 4 refers to objects removed from "a building or structure of historical, architectural or archaeological interest" or from an excavation. For purposes of the statute, it does not matter whether the excavation or removal takes place in the United Kingdom or in another country or whether the law violated is a domestic or foreign law.

Switzerland's implementing legislation, the Federal Act on the International Transfer of Cultural Property, took effect in 2005.[6] Switzerland has already negotiated its first three bilateral agreements with Italy, Peru, and Greece. Unlike the U.S. agreements, the Swiss agreements have no set time limit for expiration and do not

5. Available at http://www.opsi.gov.uk/acts/acts2003/20030027.htm.
6. Available at http://www.kultur-schweiz.admin.ch/arkgt/files/kgtg2_e.pdf.

need to be renewed periodically. With the ratification of the convention by these additional market nations, the legal geography of the trade in undocumented antiquities has changed dramatically.

United States Domestic Law and the Trade in Antiquities

In addition to the international conventions and their adoption into domestic law of the market nations, it is also necessary to consider facets of the domestic law of market nations that have an impact on the operation of the international art market. The domestic laws of the United States will be used to illustrate this. There are two aspects of illegal conduct: theft and illegal import.

1. *Stolen Property*

In countries that follow the common law of property (the United States, England, Canada, Australia, and New Zealand), a thief can never convey good title to stolen property even if the property is sold to a good faith purchaser. This contrasts with the rule of many civil law nations (such as the European continental nations) in which a thief can transfer title to a good faith purchaser under certain circumstances. Although in common law countries a thief cannot transfer title to stolen property, the original owner may be barred from recovering the property by a statute of limitation or one of the equitable defenses.

In addition to thefts of documented art works, previously unknown and unrecorded archaeological objects are looted directly from the ground. Such objects may be particularly appealing to the international art market because their existence is undocumented and there is no record of their theft. It is therefore difficult to establish their true origin and to trace such objects through normal law enforcement methods.

To combat this form of theft, many archaeologically rich nations have enacted laws that vest ownership of undiscovered archaeological objects in the nation. These ownership laws apply to any objects discovered after the effective date of the statute. An ob-

ject that is discovered after this date is stolen property. If it is removed from the country without permission, then the object retains its characterization as stolen property even after it is brought to the United States. Anyone who knowingly transports, possesses, or transfers stolen property in interstate or international commerce, or intends to do so, violates the National Stolen Property Act (NSPA).[7] Depending on the factual circumstances and the proof available to the government, the stolen property may be seized and forfeited and the individual may be subject to criminal prosecution.

This doctrine was tested in the 2001 prosecution of the prominent New York antiquities dealer, Frederick Schultz.[8] Until shortly before his indictment, Schultz was president of the National Association of Dealers in Ancient, Oriental and Primitive Art. Schultz was indicted under the NSPA on one count of conspiring to deal in antiquities stolen from Egypt in violation of Egypt's national ownership law, Law 117, which was enacted in 1983. Schultz's co-conspirator, the British restorer Jonathan Tokeley-Parry, plastered over ancient Egyptian sculptures, including a head of the Egyptian pharaoh Amenhotep III, to make them look like cheap tourist souvenirs and exported them to England. There, Tokeley-Parry restored the sculptures to their original appearance, and he and Schultz attempted to sell them in the United States and England. To this end, the two of them fabricated a fake "old" collection, attributed to a relative of Tokeley-Parry who had traveled in Egypt in the 1920s. Schultz and Tokeley-Parry reportedly soaked labels in tea and microwaved them to make them appear old. Tokeley-Parry was eventually discovered by Scotland Yard and convicted in England of handling stolen property.

7. 18 U.S.C. §§ 2314-15.

8. *United States v. Schultz*, 333 F.3d 393 (2d Cir. 2003). *Editor's Note:* 333 is the volume number; F.3d stands for Federal Reporter, Third Series; 393 is the page on which the case decision starts; in parentheses, the federal circuit court that made the decision and the year.

The legal basis of Schultz's prosecution relied on an earlier case, *United States v. McClain*,[9] in which several dealers were convicted for conspiring to deal in antiquities stolen from Mexico, which enacted its national ownership law in 1972. Schultz tried to argue that the Egyptian law was not a true ownership law and, further, that the *McClain* decision should no longer be accepted, in part because it was superseded by enactment of the CPIA. The court examined the Egyptian law and held that it was a true ownership law, both because it plainly stated that it was and because it was internally enforced within Egypt. The court also held that the *McClain* decision retained its validity despite enactment of the CPIA and that the CPIA and the application of the NSPA to antiquities taken in violation of a national ownership law could co-exist. While recognizing that there might be circumstances in which the CPIA and the NSPA would apply to the same conduct, the court held that because of differences in their nature (the CPIA being civil in nature and the NSPA being criminal) and in the elements of proof required for a violation, this did not pose an inherent conflict.

2. Illegal Import/Smuggling

The other aspect of illegal conduct is illegal import or smuggling. While goods that have been illegally exported from one country are not generally regarded as contraband once they enter another country (absent an additional agreement, such as a bilateral agreement under the CPIA, or the status of the property as stolen), illegal *import* renders the goods subject to seizure and forfeiture under the Customs laws. The U.S. Customs statute prohibits the entry into the United States of goods imported contrary to law.[10] Application of this provision is based on a variety of laws, including the NSPA (in

9. 545 F.2d 988 (5th Cir. 1977).
10. 19 U.S.C. § 1595a(c); 18 U.S.C. § 545.

the case of stolen property) and statutes that require declaration of the country of origin and value of the goods to be imported.

Illegal import often results from improper declaration of the goods upon entry into the United States. This is illustrated by the 1999 decision, *United States v. An Antique Platter of Gold*,[11] which involved a late fourth-century BCE phiale that was imported into the United States for purchase by the New York collector, Michael Steinhardt. The dealer received the bowl at the Swiss-Italian border, carried it through Switzerland, and from there, brought it to the United States. The Customs declaration forms, however, stated that the country of origin of the bowl was Switzerland (rather than Italy) and understated the value of the bowl by close to $1 million. The Second Circuit held that, because of these misstatements, the bowl was contraband property and therefore subject to forfeiture. The court's decision thereby implicitly held that the country of origin of archaeological objects is the place where they are found or excavated in modern times.

Two more recent cases illustrate the same principle. In one, the country of origin of a group of sculptures from Pakistan was declared to be Dubai, the transit point through which the sculptures were transported en route to the United States.[12] In the other, a silver rhyton from Iran was declared to be from Syria.[13] Both cases resulted in the forfeiture of the artifacts, and in the latter the dealer was convicted for making a false declaration. The principle that for the purpose of import declarations the country of origin of archaeological artifacts is the country in which the artifact was discovered is important because enforcement of the CPIA restrictions and of the NSPA as applied to looted artifacts is specific to the countries from which the artifacts originated.

11. 184 F.3d 131 (2d Cir. 1999).
12. News Release 2007.
13. Press Release 2004.

Collecting Practices of U.S. Museums

Although the law in this area can now be regarded as well-settled, particularly following the *Schultz* decision and the increase in number of bilateral agreements under the CPIA, there is an unfortunate history within the market community, including some museum professionals, of refusing to accept these fundamental legal principles despite the *McClain* decisions of the late 1970s. This is why museums in the United States, including the Metropolitan Museum of Art in New York, the Boston Museum of Fine Art, and the Getty Museum, have been returning voluntarily, but under the threat of legal action, antiquities to foreign countries, particularly Greece, Italy, and Turkey. While these artifacts arrived at museums merely as undocumented antiquities, they are now accepted to be stolen property. The question now is how many undocumented antiquities will museums acquire today that will later be proven to be stolen property.

There are times when it may not be possible to prove the illegal status of an antiquity to the extent required or under the prevailing standard of proof to the satisfaction of the law. Voluntary codes of ethics and acquisitions policies should establish a higher standard of conduct. The purpose of such codes is not only to ensure that museums follow ethical standards and avoid contributing to the destruction of archaeological sites, but also to ensure that the museum stays out of trouble.

Some natural history museums and university museums adopted voluntary policies on the acquisition of archaeological materials soon after promulgation of the 1970 UNESCO Convention. These policies generally provide that the museum will not acquire archaeological materials unless they were documented before a particular cut-off date (such as 1970) or they have an export license from their country of origin. The Getty Museum, after adopting a policy that accepted 1995 as the cut-off date, adopted a new policy

in October 2006 using the 1970 cut-off date.[14] However, the two major associations of U.S. museums, the American Association of Museums and the Association of Art Museum Directors (AAMD), were largely silent on this issue until the AAMD adopted a policy in 2004.[15] The AAMD's policy contains numerous ambiguities and loopholes and arguably does little to ensure that AAMD members will avoid acquiring stolen antiquities.

Those museums that have continued to collect classical and other types of antiquities justify these actions in numerous ways: that they are rescuing objects, that by displaying artifacts from many parts of the world they are benefiting the American public even if nothing is known of their origins or even their authenticity, and that such undocumented artifacts are chance finds, rather than the product of intentional looting of archaeological sites. All of these arguments can be refuted.

Archaeological site looting is now known to be big, well-organized business with a network of looters, middlemen, and smugglers, and it is motivated by profit. Museums cannot justify the acquisition of undocumented antiquities by arguing that these are simply chance finds. These acquisitions put additional money into the system and provide the incentive to continued looting. By acquiring artifacts that are the likely product of contemporary site looting, museums are contributing to the destruction of knowledge, rather than adding to knowledge. Because of the lack of context of undocumented artifacts, we learn little about the peoples and cultures that produced them and we cannot even tell, in most cases, which artifacts are authentic and which are forgeries. In fact, the willingness of acquirers to purchase undocumented antiquities is precisely what permits an industry in forgeries to thrive. The

14. J. Paul Getty Museum 2006. The Indianapolis Museum of Art announced a similar but temporary policy in May 2007; see W. Smith 2007, p. 1.

15. AAMD Report 2004.

historical record becomes corrupted and our ability to understand the past is permanently diminished.

A museum's contribution to the destruction of the past is also arguably a violation of its obligations as an educational institution. The only relevant categories listed in section 501(c)(3) of the Internal Revenue Code, which grants charitable tax-exempt status, are institutions devoted to scientific or educational purposes. Yet museums violate their educational purpose by contributing to destruction of knowledge of the past, and this should call into question both the validity of donations of undocumented antiquities and the museum's status as a charitable institution.

In contrast to acquisitions of questionable legal status, museums now have new opportunities for international loans, including loans for relatively long periods of time. The CPIA agreement between Italy and the United States provided the impetus for Italy to extend the period of time for which art works could be on international loan from six months to four years. These loans have allowed archaeological artifacts and works of ancient art to be seen at American museums and appreciated by our public. They also present new opportunities for research and conservation initiatives. It is to be hoped that as the United States extends recognition of export restrictions to additional nations, these countries will also lengthen the period of time for which materials will be loaned and that they will engage in more collaborative and creative projects with American museums. The future for the display and exhibition of classical and other types of antiquities in U.S. museums clearly lies in this direction with new creative and beneficial opportunities.

Conclusion

From a legal perspective, when museums acquire undocumented antiquities, there is a substantial likelihood that they are trafficking in stolen property and derogating from their educational mission. Museums need to recognize the fundamental difference between

collecting archaeological artifacts and collecting other types of art works. The collecting of undocumented archaeological artifacts provides the incentive for further looting and imposes negative externalities on all segments of society. Site looting creates direct and immeasurable harm through destruction of the historical record and the loss of the nonrenewable cultural heritage. American museums, as educational institutions, must give priority to the preservation of the cultural and historical record and must adopt stringent policies that are tailored to keeping them within the bounds of the law and deterring, rather than fostering, the demand for undocumented ancient artifacts and works of art. The question for the future is not whether museums in the United States will have archaeological artifacts and ancient art works to display. Rather, the question is how will these artifacts come to U.S. museums and will they need to be returned to their countries of origin in the next generation.

Bibliography

AAMD Report. 2004. "Report of the AAMD Task Force on Collecting." June 10. Available at http://www.aamd.org/papers.

Brodie, N., J. Doole, and C. Renfrew, eds. 2001. *Trade in Illicit Antiquities: The Destruction of the World's Archaeological Heritage.* Cambridge.

Brodie, N., M. Kersel, C. Luke, and K. Tubb, eds. 2006. *Archaeology, Cultural Heritage, and the Antiquities Trade.* Gainesville, FL.

Gerstenblith, P. 2001. "The Public Interest in Restitution of Cultural Objects." *Connecticut Journal of International Law* 16, pp. 197–246.

_____. 2003. "Acquisition and Deacquisition of Museum Collections and the Fiduciary Obligations of Museums to the Public." *Cardozo Journal of International & Comparative Law* 11, pp. 409–65.

_____. 2007. "Controlling the International Market in Antiquities: Reducing the Harm, Preserving the Past." *Chicago Journal of International Law* 8 (forthcoming).

J. Paul Getty Museum. 2006. "Policy Statement, Acquisitions by the J. Paul Getty Museum." October 23. Available at http://www.getty.edu/about/governance/pdfs/acquisitions_policy.pdf.

Mackenzie, S. R. M. 2005. *Going, Going, Gone: Regulating the Market in Illicit Antiquities.* Leicester.

News Release. 2007. "Department of Homeland Security Returns Rare Artifacts to the Pakistani Government." January 23. Available at http://www.ice.gov/pi/news/newsreleases/articles/070123newark.htm.

O'Keefe, Patrick J. 1997. *Trade in Antiquities: Reducing Destruction and Theft.* London.

Press Release. 2004. "Art Dealer Pleads Guilty in U.S. Court to Customs Violation in Iranian Antiquity Case." June 23. Available at http://www.usdoj.gov/usao/nys/pressreleases/June04/aboutaampleapr.pdf.

Smith, W. 2007. "Art Museum Limits Its Antiquities Acquisitions; Artifacts Removed from Their Country of Origin after 1970 Must Be Exported Legally, IMA Director Says." *Indianapolis Star.* May 7.

Tubb, K. W., ed. 1995. *Antiquities Trade or Betrayed: Legal, Ethical & Conservation Issues.* London.

Response to Patty Gerstenblith

Douglas E. Bradley

D R. GERSTENBLITH TAKES MUSEUMS TO TASK FOR purchasing unprovenanced works of art, and I will respond to her by addressing the way museums make acquisitions. Before I do so, I would like to point out that museum acquisitions form a highly visible but small part of the art market. Private collectors always have purchased much more, in dollars and in numbers, than museums.

Currently, museums whose directors belong to the Association of Art Museum Directors are encouraged to voluntarily accept that organization's professional practices guidelines, adopted on June 10, 2004, which call for the UNESCO Convention adoption date of November 14, 1970 as the cut-off date for a work of art from an archaeological context to be out of the country of origin in order to be considered for purchase or donation. The Snite Museum immediately adopted these guidelines as its policy.

The AAMD guidelines provide that if the provenance of an object under consideration is truly unknown, the object may be acquired by the museum if its whereabouts for the last ten years are known, and if it has continued to be out of the country of origin during that time. This is a rolling date, over which the AAMD has received much criticism, because it appears to condone a market in illicit works of art that continues to grow.

From the perspective of a curator of Pre-Columbian Meso-american art, the universe of antiquities can be divided into three categories: those that are unexcavated; those that are owned by museums; and those that belong to dealers and collectors. The third group can be divided into those that have provenances that place them out of their country of origin before 1970, and those that don't. The unprovenanced group is at the center of our discussions today. No one wants to throw these pieces away, but we all agree that looting is illegal, destructive, and immoral. Nonetheless, it will be with us as long as there are private collectors with enough money to pay for a piece of the past that they truly covet.

As the situation now stands, museums will continue to contend with collectors over the provenanced and unprovenanced objects, and the Ten-Year Rule will roll onward. Unless, of course, we promote proactive steps as a group of scholars concerned for the future of our discipline. I propose a cap that establishes an end date to the Ten-Year Rule. Before the cap date, collectors would have the chance to donate to museums any objects, provenanced or unprovenanced, and would receive appraised value tax donations. If collectors knew that they could not donate unprovenenced antiquities after the end date, their logical choice would be to give them to museums and take their donations. Objects with pre-1970 provenances could continue to be privately held, and it would be in the collectors' financial interest to ensure that they only held provenanced objects. Wipe the gray area of unprovenanced objects out of the legitimate marketplace, and the black market would be the only place where unprovenanced objects would find buyers.

Capping the Ten-Year Rule would swell museum collections and stimulate the public's legitimate interest in the ancient world. Governments of countries of origin could deal directly with museums to resolve patrimony issues through negotiations or panels of adjudication to which all participants would subscribe. Looters, dealers, and collectors of illegal objects would be stuck with numbers of objects that could not be sold to anyone but the wealthiest

collectors. The smart ones would give their collections to museums and take their write-offs.

I propose that the acceptance of the AAMD policy become mandatory for all members of the American Association of Museums (AAM), and that the cap-off date be June 10, 2014, to give collectors and museums time to respond to the influx of objects. This effort would need to be widely publicized among dealers, collectors, and financial and estate planners, but it would provide wealthy collectors with great tax benefits that could be used to underwrite museum expansions, research institutes, publications, and library development, not to mention new excavations.

Scylla or Charybdis

Antiquities Collecting by University Art Museums

Kimerly Rorschach

MY TITLE REFERS TO THE DILEMMA I OFTEN FEEL when talking, on the one hand, with archaeologists who are understandably disturbed about the looting of archaeological sites and the loss of valuable evidence, and on the other hand, with museum directors who are equally passionate about the educational value of displaying objects drawn from all cultures, no matter what their provenance, to an audience that also reflects many cultures.

My view of this issue is informed by my experiences as director of two university art museums: the David and Alfred Smart Museum of Art at the University of Chicago from 1994–2004, and the Nasher Museum of Art at Duke University since 2004. At both universities, the original impetus for collecting antiquities came from the classics departments, and those collections were later transferred to university art museums which had not existed when the departmental collecting began.[1] Both of these collections were

1. See G. Ferrari, C. M. Nielsen, and K. Olson 1998, and *A Generation of Antiquities: The Duke Classical Collection 1964–1994,* 1994.

formed as teaching tools, and that emphasis on teaching has continued to the present day. Both museums still collect classical antiquities when suitable gifts are offered, but no longer purchase, both because of the legal and ethical difficulties in doing so and because limited acquisition funds are directed to other priorities. Neither museum has a specialized curator of classical antiquities; both rely on expertise from colleagues in classics and art history.

To state the obvious, this situation is quite different from that of large museums like the Metropolitan Museum of Art and the Getty Museum, which have been actively collecting, researching, and displaying classical antiquities for decades. And yet, university museums like the Smart and the Nasher are most definitely art museums, no less than the Met, the Getty, or any other large private or public museum. Our missions are centered around collecting works of art, and sharing those collections with a more or less broad public with educational goals in mind. We believe that classical antiquities have tremendous educational and aesthetic value, even when removed from their original context and even when their original context is entirely unknown. And although most university art museums are too small to be considered truly "universal" museums,[2] we believe in the concept. It is also worth noting that, of the approximately two hundred leading art museums in North America represented by the Association of Art Museum Directors (AAMD), over 20 percent are university art museums.

But university art museums, by their nature, belong to universities, much larger institutions with much broader educational missions. American universities are engaged in research on every imaginable topic in nearly every corner of the globe. In pursuit of their educational missions, universities engage in partnerships with other universities, businesses, governments, NGOs, and many other types of organizations. Our university colleagues include not just curators and other museum personnel, but academic art historians,

2. See I. Karp et al. 2006, pp. 247–49.

archaeologists, anthropologists, classicists, area studies specialists, legal scholars, historians, economists, and scholars in many other fields, whose work may rely on relationships in Italy, Greece, China, Egypt, Mexico, India, Afghanistan, Israel, Iraq, or other antiquities "source nations," or almost any other country on earth.

Given what I believe to be the demonstrated connection between the current antiquities market and the present-day looting of archaeological sites—with the concomitant destruction of archaeological evidence—and given our university mission to uphold humanistic values and create new knowledge, broadly defined, university art museums must be extremely cautious about participating in that market, even indirectly. In support of our mission (which is broader than that of stand-alone art museums), we must take account of the interests of our colleagues in other scholarly fields, especially since our teaching mission as university museums relies on the ability and willingness of faculty and students in these fields to work with the objects we collect.

While good policies are essential to every well-managed organization and business, I would argue that they are especially critical in the university context. Large research universities such as Duke and the University of Chicago are vast and decentralized, and are not managed in the relatively tight top-down fashion characteristic of most stand-alone museums. However, large American research universities generally receive very significant amounts of federal money as grants to fund research, mostly in science and medicine, and these grants require university-wide compliance on numerous fronts including employment standards and conditions, nondiscrimination, worker documentation, clear and standardized accounting for grant monies, and a host of other federally mandated issues. Clear written policies applied broadly and consistently, especially in areas where compliance must be assured, are essential to effective management and decision-making in this institutional context.

In my opinion, the guidelines in the "Report of the AAMD Task Force on the Acquisition of Archaeological Materials and

Ancient Art,"[3] and most specifically the suggested "ten-year rule," do not provide a workable policy basis, because they do not sufficiently or clearly acknowledge international law or the way U.S. law is evolving to take foreign laws into account. To base our policies on these current AAMD guidelines creates too much risk and too much exposure for both the university museum and the parent institution. Therefore, following the Getty Museum and others, the Nasher Museum is adopting clearer policies regarding the acquisition of antiquities. We will use the UNESCO convention date of November 17, 1970 as the date before which we must be satisfied that any antiquities under consideration as acquisitions were out of the country of origin (or removed legally after that date). Depending on the individual situation and relevant foreign laws, we may have to go back even further in time, but we recognize the importance of articulating a specific, well-justified date, sufficiently removed from the present day, by which objects must be documented. Our new policies will not make exceptions for so-called "orphan objects," given the difficulty of identifying such objects with certainty in the absence of documentation. At the present time, we believe that this policy best reflects our duty to our university, to our audiences, and to the "public trust" that all museums must uphold.[4] We will of course regularly evaluate our policy in light of current law and best practices.

These dilemmas are illustrated by a recent gift of antiquities to the Nasher Museum (figs. 1–3). In 2005 we were offered an anonymous gift of some 250 antiquities, mostly Greek in origin, with a number of pieces of very high quality and interest. It was clear that this gift would complement, and indeed greatly enhance, our existing collection. Most of the major pieces were documented from the 1950s and 1960s, a few pieces were documented from the 1970s and 1980s, and a few lacked any specific documentation. Our existing

3. AAMD Report 2004.
4. See J. Cuno 2004.

Figure 1. Gold disc with bees, 700–600 BCE. Courtesy of the Nasher Museum of Art, Duke University.

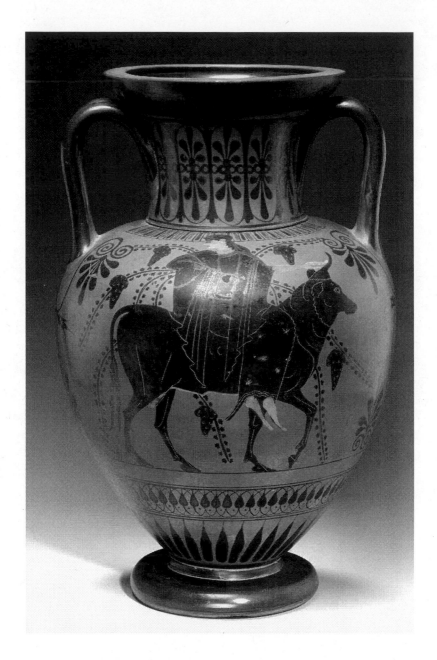

Figure 2. Europa and the bull, ca. 520–510 BCE. Courtesy of the Nasher Museum of Art, Duke University.

Figure 3. Dionysos and Silenus, ca. 480–475 BCE; attributed to the Kleophrades Painter. Courtesy of the Nasher Museum of Art, Duke University.

policies were fairly vague, simply citing the AAMD guidelines and our intent to comply with all applicable laws.

After additional research, consultation with colleagues in classics and art history, and consultation with our legal counsel, we determined to accept the gift under our then-existing policies, since it appeared certain that none of the pieces had been recently acquired by the donor.[5] This gift was the subject of a spring 2007 seminar, taught by professors Sheila Dillon of Duke's Department of Art, Art History, and Visual Studies, and Carla Antonaccio of the Department of Classical Studies. With Malcolm Bell of the University of Virginia, Antonaccio is also co-director of the Morgantina excavations in Sicily. Under the direction of their professors, the seminar students researched and catalogued the collection, and the results of their research will be published, so that these holdings will be known to the public and interested scholars, and to any possible claimants. The collection is also on exhibit at the museum, in a beautiful installation planned by Professors Antonaccio and Dillon in collaboration with our curator of academic programs Anne Schroder, and thus benefits a broader local audience as well. I am very pleased that we were able to acquire this wonderful collection of ancient Greek antiquities, but it was a difficult acquisition to make because of the legal complexities and our then-vague policies. Although it sounds contradictory, I am equally pleased that this acquisition led to a review and tightening of our antiquities acquisition policies. The new policies offer much clearer, more defensible guidelines, and will help us communicate with potential donors in a more straightforward and productive manner.

As discussed above, our new policies are also called for in light of our role as part of a major research university whose mission is to create and disseminate new knowledge. I also believe that, in an

5. I must acknowledge, however, that under our new policies we would only be able to accept the pieces documented prior to November 17, 1970.

age of globalism, American museums must be particularly sensitive to how our actions may be perceived in other countries. For example, the U.S.-led war in Iraq, which is not broadly supported by the international community, has led to large-scale uncontrolled looting there, which the United States has done little to prevent. To disregard the cultural patrimony concerns of other countries, whether or not we share them, only compounds ill will toward the United States. For university museums especially, it seems clear to me that collecting undocumented antiquities at the present time cannot be condoned. And I cannot help feeling that stand-alone museums, whose missions are also fundamentally educational, ought increasingly to ponder the adverse implications of advocating such collecting in the present global environment, despite the benefit that the display of undocumented antiquities can undoubtedly bring to their audiences.

Bibliography

AAMD Report. 2004. "Report of the AAMD Task Force on Collecting." June 10. Available at http://www.aamd.org/papers.

Cuno, J., ed. 2004. *Whose Muse? Art Museums and the Public Trust.* Princeton and Oxford.

Ferrari, G., C. M. Nielsen, and K. Olson, eds. 1998. *The Classical Collection.* David and Alfred Smart Museum of Art, Chicago.

A Generation of Antiquities: The Duke Classical Collection 1964–1994. 1994. Durham, NC.

Karp, I., et al., eds. 2006. "Declaration on the Importance and Value of Universal Museums." In *Museum Frictions*, pp. 247–49. Durham, NC.

Response to Kimerly Rorschach

Charles R. Loving

I THANK KIMERLY RORSCHACH AND JAMES CUNO FOR providing a range of opinions and policies presently found within American art museums regarding the acquisition of antiquities and archaeological objects. Archaeologists, on the other hand, are far more unified in their positions and have been quite successful in bringing their concerns to broad international attention.

Despite our differences, many archaeologists and art museum directors agree on fundamental matters:

1. Archaeologists should excavate archaeological objects.
2. Objects from illegal excavations should not knowingly be acquired by art museums.
3. Objects with known provenances should have been imported before 1970, or should have legitimate export licenses, in order to be considered for acquisition by art museums. The Association of Art Museum Directors' statement on this matter indicates, "Member museums should not acquire any such works of art that were removed after November 1970 regardless of any applicable statutes of limitation and notwithstanding the fact that the U.S. did not accede to the [1970 UNESCO] Convention until 1983."

4. Should new provenance information come to light following
 the acquisition of objects having incomplete provenance, and
 should this information indicate that the UNESCO Conven-
 tion was violated, these objects should, in most cases, be re-
 turned to their countries of origin. There may be exceptions
 for special circumstances where the country of origin does not
 properly value or care for artworks. (See the paper by Mary
 Ellen O'Connell in this volume.)

The primary matter on which archaeologists and art museum
directors often disagree is how best to facilitate the study, preserva-
tion, and restitution of current "orphan objects" (those ancient and
archaeological objects with incomplete or unknown provenance
that are already out of their countries of origin), while simultane-
ously discouraging further looting. If "orphan objects" were to be
unilaterally refused by public institutions, they would be relegated
to the private market—possibly to a black market, where there
would be little opportunity for research or restitution. Therefore,
for "orphan objects," the Association of Art Museum Directors has
recommended that its members "take into account . . . whether the
work of art has been outside of its probable country or countries of
origin for a sufficiently long time that its acquisition would not pro-
vide a direct, material incentive to looting or illegal excavation; . . .
a period of 10 years or more should be required." (The Association
of Art Museum Directors statement and the UNESCO Convention
on Cultural Property Implementation Act, CPIA, detail additional
criteria for utilizing the ten-year exemption.)

Some art museum professionals are not comfortable with this
"ten-year rule" rolling forward indefinitely, even though the CPIA
provides limited museum exemptions of three- and ten-year peri-
ods, depending upon specific circumstances. Therefore, I suggest
that art museum directors and curators might agree that the "ten-
year rule" should expire in June 2014 (ten years after its inception;
seven years from this coming June). Such practice would place art

museums on high moral ground by providing a limited opportunity for "orphan objects" already out of their country of origin to be published, to be studied, and, if new provenance information became available, to be returned.

Finally, I express support for Dr. Bell's concept of a "rolling date": that is, his recommendation that museums be able to acquire objects with documentation establishing that they have been out of their countries of origin for "a period of at least thirty or forty years." I note that the CPIA already provides an exemption if the artwork "has been within the United States for a period of not less than twenty consecutive years and the claimant establishes that it purchased the material or article for value without knowledge or reason to believe that it was imported in violation of law" (SEC.312.28).

In summary, I am suggesting a two-part resolution for "orphan objects":

1. Objects with documentation establishing that they have been out of their countries of origin for at least ten years (or with a legitimate export license) could be acquired by museums until 2014.
2. After 2014, objects with incomplete provenance would need to have documentation establishing that they have been out of their countries of origin for at least twenty years (or have a legitimate export license).

In essence, I would hope that most archaeologists and art museum directors might agree that it is better for unprovenanced objects already outside of their countries of origin to be in public collections, rather than in private hands.

Response to Kimerly Rorschach

Robin F. Rhodes

Whatever the final resolution on provenance adopted by the Association of Art Museum Directors, there is no question that attitudes and practices in the collection of antiquities have already changed and that new strategies of exhibition will necessarily follow.

Art exhibitions have traditionally been displays of objects that are intrinsically valuable for their beauty, their uniqueness, and their authenticity. There are exceptions, however, and as the free flow of antiquities slows, it might be helpful to consider them: for instance, single-object exhibitions, in which one notable antiquity is displayed and contextualized as fully as possible through accompanying didactic panels and displays; or the collection and display of casts of ancient art, either to supplement genuine antiquities or as stand-alone collections; or even, in the case of architectural displays, exhibitions that are fabricated completely from scratch. Here I am thinking specifically of the exhibition of the seventh-century BCE temple from Corinth held here in the Snite Museum of Art from January to March 2006. I would like to briefly present it as a possible model for one type of new exhibition strategy (see my "The Corinth Project Exhibition: A Prospectus," Notre Dame, 2007, and figs. 1–2 here).

Figure 1 (opposite). Corinth temple exhibit, stations 1, 2, and 7. Courtesy of the author.

Figure 2 (above). Corinth temple exhibit, station 4. Courtesy of the author.

Whether in a university art museum or in a museum like the Metropolitan or the Art Institute of Chicago, architectural exhibitions are always peculiar cases: architecture is certainly fine art, but most museum displays of architecture are necessarily exhibitions of *images* of architecture. In the case of ancient architecture, those images invariably surround evocatively weathered and worn fragments of the original building.

The Corinth temple exhibit was made for an art museum, but not a single object in the show is inherently valuable through its antiquity: each has been made in the past three years. Its archaeological nature is clear in its didactic nature and in its emphasis on methodology and context. But the Corinth temple exhibit attempts

to go beyond the purely didactic and documentary. It is an overwhelmingly interactive installation, and in its overall design it strives to *be* architecture, to create an architectural experience through the physical reality of three-dimensional forms. Through its own presence and manipulation of space it attempts to reflect something of the most basic nature of Greek monumental architecture: its mass, its materials, its textures, its ability and intent to manipulate the viewer along specific processional paths. To that end, diagonal walls lead from one station to the next, and as one station emerges another is hidden. And throughout a distant landscape beckons: the physical and, to some extent, the religious environment of the temple are re-created through a large-scale video diorama of the temple in the landscape, the weather, and the sounds of Corinth.

The Corinth temple exhibit represents the cooperative effort of a large variety of professionals and the synthesized sensibilities and skills of archaeologists, architects, art historians, ceramicists, sculptors, printmakers, industrial designers, and graphic designers toward the goal of creating an installation that is meaningful to a wide variety of viewers and that is appropriate not only in the more specialized context of museums of archaeology, but also in the broader context of art museums on the university campus and elsewhere. The traditional museum focus on romantic engagement with the original artifacts of antiquity is superseded by direct and directed interaction with the methods of archaeology and architectural reconstruction and, at least as important, by the re-creation of the architectural experience itself.

In the contemporary context of changing attitudes and policies toward the acquisition and exhibition of antiquities, and with the blurring of boundaries between traditionally distinct types of museum and exhibition, the time seems right to rethink traditional exhibition practice—particularly in the case of architecture, whose experience has rarely been captured in exhibitions—and to formulate new approaches appropriate to broader goals and a variety of venues.

Antiquities without Provenance

The Original Sin in the Field

Stefano Vassallo

Fɪʀsᴛ ᴏғ ᴀʟʟ, ʟᴇᴛ ᴍᴇ ᴛʜᴀɴᴋ ᴍʏ ғʀɪᴇɴᴅ ʀᴏʙɪɴ Rhodes for inviting me to participate in this symposium and to bring testimony from one of the countries that is most deeply touched by the problem of the illegal looting of archaeological sites, and by the problem of the dispersion of antiquities in the clandestine market and their acquisition by museums and private collectors all over the world. My testimony is that of an archaeologist working as an officer of the Superintendence for the Antiquities, the institution that for over a hundred years now has been in charge of the management, preservation, and investigation of the archaeological heritage of Italy.

This symposium touches upon a series of problems that have become particularly critical over the past few months: problems of stewardship, moral responsibility, and professional ethics. They are of concern to a variety of professionals, in fields such as archaeology, museology, art history, and international law. In my paper

I am very grateful to Clemente Marconi for discussing these problems with me, and for the translation of my paper.

I will be focusing on stewardship, and I will offer an archaeological perspective.

My initial argument is that the removal from the ground of any archaeological object in the course of illegal excavations, and its dispersion through the clandestine market, always involves major damage, not only to the archaeological heritage of the nation to which the object belongs, but also to scholarship on ancient history and ancient art. It is important to be aware of the fact that when an unprovenanced ancient object—be it a statue, a coin, an inscription, or a vase—is put on display on the shelf of a museum or in the living room of a private collector, that object has made a long journey.

There may be curators of museums and collectors today who would still prefer not to think about that journey, and who content themselves with labels such as "without provenance," "provenance unknown," or "said to be from" However, such labels do not tell the truth, since antiquities always have a provenance, and when they lose that provenance, their cultural value and their historical meaning are lost forever.

The first step in the journey is the clandestine dig, what I call the original sin in the field. Clandestine digs do serious harm to archaeological research, involving the complete destruction of stratigraphies and of ancient structures. It is for this reason that in Italy, well before the Unification, and since the beginning of the nineteenth century, this type of activity has been classified as illegal, and regarded as a criminal act against the cultural heritage of the nation. To give you an example of such criminal acts, I would like to show you a series of pictures taken from two sites in Western Sicily, which fall under my personal supervision. Needless to say, images like these could be taken from hundreds of other archaeological sites throughout Italy, which are exposed every day to the same kind of criminal activities.

Montagna dei Cavalli is an important settlement in central Sicily dating to the early Hellenistic period, best known for the important pieces of jewelry that have emerged from its cemeteries.

Figure 1. Clandestine trench with Hellenistic house wall, Montagna dei Cavalli, Sicily. Courtesy of Stefano Vassallo and the Soprintendenza BB.CC.AA di Palermo.

Clandestine digs are systematically violating this site, destroying its public spaces, its houses, and its cemeteries (fig. 1). In order to recover a few objects worth selling in the illicit market, an entire archaeological site is being destroyed, voiding the evidence necessary for future archaeological investigation.

Even worse are the clandestine digs perpetrated during the campaigns of excavations run by the Superintendence. In the course of the excavations at the site of Himera, the Greek colony on the north coast of Sicily, clandestine nighttime digs systematically devastate the archaeological layers uncovered the day before. The images in this paper cannot give a full sense of the extent of the devastation produced in archaeological sites by clandestine digs.

Now, I would like to draw your attention to the consequences of clandestine digs for the objects that are the targets of the thieves. Clandestine digs, in fact, cause serious trouble for those entrusted with the study and display of antiquities, once the antiquities have reached the end of their journey. Based on my personal experience, which comes from fighting for many years now against clandestine digs, I can confidently say that in general the statements by looters and dealers concerning the provenance and the authenticity of antiquities are untrustworthy. Even when that information appears reliable, it turns out to be very difficult to validate in the field.

For this reason, I believe that curators and directors of museums who decide to buy antiquities without provenance should not give too much credence to the information that comes from dealers. Otherwise, serious problems will emerge, as we all know too well (fig. 2):

1. There will be serious doubts about the authenticity of an object (for example, the Boston Throne) or of part of an object (for example, the inscription on the fibula from Praeneste).
2. There will be uncertainty about the dating of the object and its original context (sanctuary? cemetery? house?).
3. There will be uncertainty about the place of production of the object.

I do not have the time to discuss this specific issue, but there are dozens and dozens of antiquities from Sicily that have made their sudden appearance in museums, private collections, and even scholarly journals, and that are either fakes or cultural aliens within the context of Classical art.

This leads to my next question: When an object is authentic but its original context is lost, what is left of it? Only an aesthetic object remains, beautiful to look at, but which has little to do with the way we look today at ancient art. It is not just beauty that catches our attention today, but the way works of art functioned within their society, the response to them by their public, and their recep-

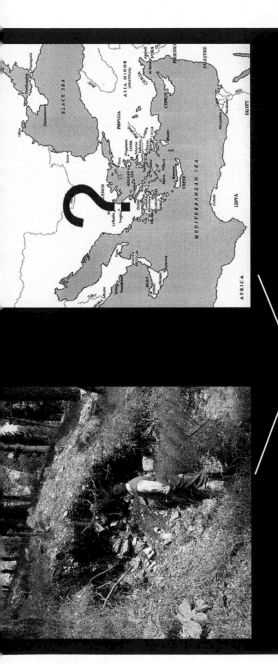

OBJECTS WITHOUT PROVENANCE

- Doubts about authenticity
- Loss of strategic context
- Loss of strategic dating elements
- Loss of original context, sanctuary ? Cemetery ? Urban center ? Farm

Figure 2. Dramatic effects of illegal excavations. Courtesy of Stefano Vassallo and the Soprintendenza BB.CC.AA di Palermo.

tion by later generations and cultures. A correlated question, of course, is what is left to the countries of provenance of these objects as a consequence of this quest for beauty. My answer is this:

1. great damage to the archaeological sites;
2. the plundering of the cultural heritage of the nation that owns them;
3. offense to the people who not only own those objects, but base their cultural identity on them.

In my view, and on this I believe that many of my colleagues in the archaeological field will agree, curators and collectors of today can no longer ignore the fact that clandestine digs are a cancer (fig. 3), nor that the acquisition of looted antiquities is the conclusion of a journey from the field, from looters, to dealers, to museums and collectors, until the objects are lost to scholarship. Nor can they ignore the fact, finally, that crime organizations like the Mafia are often directing this journey, moving antiquities in parallel with drugs or using them in money laundering. I am not talking, of course, only of American museums and collectors. In fact, the problem also involves, and on a larger scale, several European institutions and collectors.

I am aware of a change of mentality over the past few years regarding the looting of antiquities and its ethical implications, a change for which much credit must be given to the archaeological community, and to many colleagues and friends working here in the United States. The reason my comments today are still so strong, however, is because of my personal experience as an archaeologist operating in a country that is a victim of looting, a continuing, daily experience of the devastation and dispersion of the archaeological heritage of Italy.

A frequent objection to my line of argument is that the acquisition and the display of antiquities without provenance can be a good thing, in light of the fact that in this way objects are given the

OBJECTS WITHOUT PROVENANCE · A Long Journey

From untouched stratigraphies

An illegal path

Tombaroli

Mafia and other Crime Organizations

Dealers

Museums and Collectors

Figure 3. The illegal path of unprovenanced antiquities. Courtesy of Stefano Vassallo and the Soprintendenza BB.CC.AA di Palermo.

chance to surface once again. Another frequent objection is that to return these objects to my country is not a good thing, since they would end up in the storerooms of the Superintendence, while on the shelves of international museums they would be visible to the general public and would fulfill an important educational role. It is my intention now to argue against these two objections.

First of all, it is important to realize that as long as museums and collectors keep buying antiquities from the illicit market, clandestine digs will continue and the crime organizations that are behind the looting and illegal trade will continue to thrive. Second, it must not be forgotten that there is an intrinsic link between antiquities and their place of provenance. This alone argues for their return. Third, the depletion of the cultural heritage of a nation through the trading and buying of looted antiquities is, in fact, not only unethical but also against the law. Antiquities without provenance are stolen goods, and to buy them is equivalent to acting as a fence. This has been the case for Italy since 1913, when innovative laws were enacted for the purpose of protecting its cultural heritage. Finally, let me say that the restitution of looted antiquities is an act of expiation for the crime committed in buying them: a moral crime, first, and sometimes also a crime against the law, based on international law.

I would like to say one last word on the problem of museum display. We all acknowledge the fact that international museums contribute greatly to the enhancement of the importance of the archaeological heritage of Italy. This role is fully legitimate in the case of historical collections, legal acquisitions, and loans. One should not forget, however, that from the end of the nineteenth century, and in particular in the years between 1913 and 1939, Italy asserted both the principle that the state is the owner of all objects, movable and unmovable, which are of artistic, historical, or archaeological interest, and the principle that the state takes charge of the archaeological stewardship of its territory, through its Superintendences. These two principles have gradually transformed the meaning and the function of archaeological museums, by insisting on the link

between excavation, provenance, antiquities, and museums. Today, in Italy, the idea is that the antiquities must be displayed in local archaeological museums that are closely connected to their place of provenance. This idea is of course not new, but goes back to the end of the nineteenth century. One need only think of the Hermes and Dionysos from Olympia, of the Delphi charioteer, or of the Blonde Boy from the Acropolis. About these three pieces I would like to ask: How would the state of our knowledge of the history of Greek art be changed if those pieces had been looted and illegally traded, and put on display far away from their place of provenance, with labels stating "said to be from Greece"?

I would like to conclude my paper with the well-known case of an object with which I am particularly familiar: the phiale from Caltavuturo, an object that was looted and illegally traded, but which has made its way back to its place of provenance (fig. 4).

The phiale was excavated by *tombaroli* (tomb robbers) in 1980. Until 1991 the phiale remained in Sicily, passing through the hands of several Sicilian collectors and dealers. To those years date the first contrasting accounts regarding the authenticity and provenance of the object. In 1991 a Sicilian collector, Mr. Cammarata, illegally exported the phiale to Switzerland. Here, with the help of two dealers and intermediaries, Mr. Veres and Mr. Haber, the phiale was sold for $1,200,000 to a private collector in New York, with fake customs bills of entry and after examination by museum curators. In 1995 Italian prosecutors began a criminal investigation, which led to a sentence by American judges against the collector and the Swiss dealers for the infringement of the customs laws.

In 1999 the phiale made its way back to Italy, with much media attention. It soon became the symbol of the repatriation of the stolen cultural heritage of Italy. Soon after its restitution, the phiale was the subject of scientific analysis, which confirmed its authenticity. In 2002 Italian judges gave possession of the phiale to the Superintendence of Palermo, and my office decided that it should be put on display in the Museum of Himera, not far from Caltavuturo, said to be the place of provenance of the phiale. Since then, the

Figure 4. Journey of the golden phiale. Courtesy of Stefano Vassallo and the Soprintendenza BB.CC.AA di Palermo.

phiale has been the centerpiece of many exhibitions and cultural events, including a show in Zurich in 2004 and a show in Marseille in 2006. Most important, the return of the phiale to a place near Caltavuturo has been a source of pride for the entire population of that town, which is now working on the construction of a local museum. In this regard, the return of the phiale to its place of provenance has been a major contribution to the social and cultural growth of the local community. I am sure the private collector in New York would be most happy to hear about such wonderful developments in that tiny little town in Sicily.

Bibliography

Antichità senza provenienza. 1995. *Bollettino d'Arte*, LXXX, 91.

Antichità senza provenienza II. 1997. *Bollettino d'arte*, Suppl. 101–2.

La circolazione illecita delle opere d'arte. 2000. Atti del 5° Convegno Internazionale, 3–6 May 1999. *Bollettino di Numismatica*, Suppl. 34–35.

La circolazione illecita delle opere d'arte. 2001. Atti del 6° Convegno Internazionale, 12–16 June 2000. *Bollettino di Numismatica*, Suppl. 36.

Traffico illecito del patrimonio archeologico e problematiche di contrasto. 2002. Atti del 7° Convegno Internazionale, 25–28 June 2001. *Bollettino di Numismatica*, Suppl. 38.

Response to Stefano Vassallo

Michael Lykoudis

I, TOO, WOULD LIKE TO THANK ROBIN RHODES FOR his invitation to be a respondent in this symposium. First of all, let me say that I have no disagreement whatsoever with Stefano Vassallo's position about the looting of antiquities. The removal of such antiquities illegally is simply indefensible. Professor Vassallo's points do, though, raise several important philosophical questions.

The first question is, How do we assess the legality of the removal of antiquities in the absence of regulating laws or in the absence of a legitimate government? How do we even assess what constitutes a legitimate government?

The second question, and perhaps the more important one, is, To what extent are monuments that belong to a particular culture also part of a world heritage? Without the display of such antiquities in settings outside their country of origin, how can we make the claim that they belong to all humanity?

The classic case in point is the issue of the Parthenon Marbles currently in the British Museum. They were removed without the permission of the Greek people but in consultation with the ruling Ottomans. Even so, the British used several tools of persuasion to obtain the necessary permissions to transport the marbles to London. In their defense, at that time, the British had no reason to

believe that the Ottomans did not constitute a legitimate government.

The removal of the marbles to London was a catalyst for the transfer of knowledge and Greek culture to Europe. In fact, they have contributed to a worldview that embraced classical architecture on many continents. In an ironic twist, the marbles' presence in London could be tied to the eighteenth- and nineteenth-century wave of democratic thought in Europe identified with neoclassical forms and the romantic notion of a liberated Greece.

Another case is the removal of obelisks from Egypt and their insertion into the city of Rome, where they have stood for hundreds of years. And up until the seventeenth century the lions of Venice's arsenal stood in Porto Leone in Greece, or what is now known as Piraeus. Now the obelisks and lions are as much a part of the Italian and Venetian national and local identities as they are Egyptian and Greek. As we observe history from the vantage point of our modern world, it is difficult to imagine Rome without its obelisks, Venice without its lions, or the spread of classical ideas throughout Europe without such pieces as the Parthenon Marbles. It is indeed difficult to imagine any part of world in which this kind of cross-pollination was absent.

We should not forget that in the places we admire most today, the inhabitants used pieces of antiquity that belonged to other cultures to fashion new identities and ideas. There are few ideas in the world today that can claim a singular origin. Most cultures and their artifacts are products of societies from multiple places and times. It is the transfer of antiquities around the world that has provided one source for the making and fusion of new cultures.

With respect to the return of the Parthenon Marbles, I have this to say: The time is right for their return, given the emblematic and particular nature of the issue. But I would also argue that their current resting place in John Russell Pope's galleries in the British Museum is a far more enlightened setting than Bernard Tschumi's uninspired box on the Makriyianni site. Pope designed a set of

rooms that defer to the articles displayed while at the same time drawing inspiration from the works themselves to create new spaces and ideas. Tschumi's design tragically misses the opportunity to set the marbles in dialogue with their context or to make a statement about the journey and contribution of the marbles to the world. That the design pays lip service to the plan of classical temples is of little consolation. The museum does nothing to stitch together the context of the Acropolis and the nineteenth-century buildings that are still on the Makriyianni site. Tschumi's museum design actually undermines one of the major underpinnings of the Greek argument on why the marbles should be returned. The current museum design reinforces the rupture of historical continuities and their identity, and it does little to support the argument that the transfer and display of the marbles would contribute either to their original context or to their adaptation for the creation of new identities.

We can and should return the Parthenon Marbles to Greece. But can we use this opportunity to realize and express that we are one world with one history as much as we are many cultures with many histories, and that these two opposite views are at once both complementary and necessary? If we are to successfully make a better future, we need to understand the dialogue between the unifying role of the universality of the human condition at one end of the spectrum and the particular role that identity plays in regional and local cultures at the other. The manner in which we return the Parthenon Marbles and display them will reflect how we see our collective and individual histories and indeed our futures.

Rethinking the Remedy of Return in International Art Law

Mary Ellen O'Connell
with Maria Alevras-Chen

IN 2002, IRAQ, UNDER THE LEADERSHIP OF SADDAM
Hussein, requested that Germany return the Ishtar Gate.[1] The massive structure of glazed brick built around 600 BCE was one of the outstanding features of the ancient city of Babylon.[2] German architects and archaeologists excavated it between 1899 and 1917 with the permission of Ottoman authorities. The Germans performed a monumental job of restoration and housed the Gate in the Pergamon Museum, which, in turn, underwent a major restoration completed in 2006. When Iraq made its request, it was joining a number of other countries in making similar claims on wealthy Western states holding important artifacts of ancient cultures in their imposing museums: the Elgin or Parthenon marbles from present-day Greece; the bust of Nefertiti from Egypt; and the obelisk from Ethiopia, to name a few prominent examples.[3] Italy, in fact, agreed

1. D. Blair 2002.
2. J. Marzahn 1995.
3. For a discussion of such cases, see J. H. Merryman 2006.

to return the obelisk.[4] To many it seemed the British would have to return the Parthenon marbles.[5] Iraq's chances looked promising of getting the Ishtar Gate — that is, until the March 2003 invasion by the United States, Britain, and Australia. Overthrowing the regime of Saddam Hussein unleashed chaos in Iraq, which by 2006 was being called a civil war.[6] In such circumstances, returning a monumental work of antiquity makes little sense.

Twenty years ago, John Henry Merryman, the dean of international art law scholars, wrote with great concern about the growing demands by states to possess antiquities that originated on their territories: "The repeated assumption, or assertion, of the premise that cultural objects belong in their nations of origin gives it [repatriation] growing momentum. As consensus grows, law may not be far behind."[7] He appears to have been right: the dominant principle of international law by the time of the Iraq invasion was that of return. Yet three years later, as a result of that war and other developments, the principle appears to be weakening.

This essay explores the rise of the repatriation or return principle, which first appeared in the law of armed conflict. It then discusses the invasion of Iraq and the growing indications that the principle of return may be weakening in favor of the principle of protection.

The Rise of the Return Principle

In their book *Law, Ethics, and the Visual Arts*, Merryman and A. E. Elsen open with the history of looting and early responses to the claim "to the victor go the spoils." Looting in wartime has been pro-

4. BBC News 2005.

5. D. Rudenstine 2001, pp. 69, 70–71.

6. H. Cooper and D. E. Sanger 2007.

7. J. H. Merryman and A. E. Elsen 2003, p. 266. See also K. A. Appiah 2006, p. 38; J. Hughes 2000, p. 131; J. H. Merryman 1986.

gressively declared unlawful. Eventually, the law began requiring the return of looted objects. The first codified requirements to return looted property were found in the Versailles Treaty ending the First World War. This section discusses the Versailles Treaty, important precursors to it, and post-Versailles developments.[8]

From the very start, international law has been concerned with property protection in war. Hugo Grotius (1583–1645), the father of international law, included property protection in his discussion of the proper conduct of war. Although Grotius did not write specifically about cultural property, Emmerich de Vattel (1714–67), the next most influential international law scholar after Grotius, did. Vattel recommended that in the conduct of war, respect should be shown for the principles of humanity, forbearance, truthfulness, and honor.[9] He advised that complying with the law of war would diminish interest in retaliation and foster trust, both of which are necessary to achieving peace. With respect to cultural property, Vattel urged restraint:

> For whatever cause a country be devastated, those buildings should be spared which are an honor to the human race and which do not add to the strength of the enemy, such as temples, tombs, public buildings, and all edifices of remarkable beauty. What is gained by destroying them? It is the act of a declared enemy of the human race thus wantonly to deprive men of these monuments of art and models of architecture. . . . We still abhor the acts of those barbarians who, in overrunning the Roman Empire, destroyed so many wonders of art.[10]

8. This section is adapted from M. E. O'Connell 2004, p. 323. The term "return" is used here as the broadest of several terms used in international art law. Alternatives with somewhat narrower meanings include "repatriation" and "restitution."

9. E. de Vattel 1916, p. 338.

10. Ibid., pp. 293–95.

The eighteenth century was, in fact, relatively free of plundering, but then,

> ... the lust for spoliation revived once again, bursting forth with unprecedented violence. The wars of the Revolution, the Consulate, and the Empire show that France, with her well-known ruthlessness, plundered palaces, museums, and churches in the provinces conquered by her armies.... Just as Rome once did, Paris was destined to enrich herself with the artistic treasures of conquered peoples; those treasures were regarded as trophies of victory and the adornments of a nation that, by initiating the love of freedom in Europe, deserved to become the center of sciences and arts.[11]

In the negotiations of 1815 that ended the Napoleonic wars, delegates demanded that France return looted objects.[12] These demands not only triggered the development of an international legal prohibition on the pillage of cultural property, they also gave rise to the remedy of return.

About fifty years later, the United States codified property protection obligations for its soldiers when President Lincoln, in General Orders no. 100, approved the drafting of a code of military conduct on the battlefield by Francis Lieber. "Lieber's Code was the first attempt to set down, in a single set of instructions for forces in the field, the laws and customs of war."[13] It included protections for cultural property and restrictions on pillage. The Lieber Code, the Declaration of St. Petersburg, and the *Oxford Manual* were important milestones on the road to the Hague Peace Conferences of 1899 and 1907, which were called to promote peace and to mitigate the horrors of war. The annex of regulations on land warfare of the Fourth Hague Convention of 1907 includes protections for cultural

11. J. H. Merryman and A. E. Elsen 2003, p. 2, quoting C. De Visscher 1949, pp. 821, 823 (paragraph break omitted).

12. J. H. Merryman and A. E. Elsen 2003, pp. 5–8.

13. D. Fleck 1995, p. 18.

property and an obligation that occupying powers maintain law and order. The Fourth Hague Convention remains in force and binds the United States.

The Hague Peace Conferences did not prevent the First World War or significantly mitigate the suffering of soldiers or civilians. Parties to the conflict did accept Hague law as governing, and some attempts were made to hold individuals and states accountable for violations. In addition to requiring Germany to provide substitutes for objects destroyed in the war, Articles 245 and 246 of the Treaty of Versailles required return of objects taken in war:

> Within six months after the coming into force of the present Treaty the German Government must restore to the French Government the trophies, archives, historical souvenirs or works of art carried away from France by the German authorities in the course of the war of 1870–1871 and during this last war, in accordance with a list which will be communicated to it by the French Government; particularly the French flags taken in the course of the war of 1870–1871 and all the political papers taken by the German authorities on October 10, 1870. . . .

> Germany will restore to His Majesty the King of the Hedjaz the original Koran of the Caliph Othman, which was removed from Median by the Turkish authorities and is slated to have been presented to the ex-Emperor William II. Within the same period Germany will hand over to His Britannic Majesty's Government the skull of the Sultan Mkwana which was removed from the Protectorate of German East Africa and taken to Germany. The delivery of the articles above referred to will be effected in such place and in such conditions as may be laid down by the Governments to which they are to be restored.[14]

Despite Versailles and other treaties—and the existence of the League of Nations—German and Japanese leaders, imbued with a

14. Hague Convention IV 1907 (paragraph breaks omitted).

sense of their moral and cultural superiority and of their destiny to rule other peoples, initiated wars without regard for the prohibitions on the use of force and the rules on the conduct of war. The Nazis systematically plundered or destroyed cultural property wherever they went. In addition to the well-known theft of cultural property from Jews and other victims, the Nazis destroyed 427 museums in the Soviet Union.[15] Following the war, around two hundred high political, business, and military leaders in Germany and the Far East were tried and punished for these law violations.

At Nuremberg, two leading Nazi officials, Hermann Goering and Alfred Rosenberg, were charged specifically with plunder of cultural property.[16] The Allies, in turn, are criticized for the terror bombing of the treasure city of Dresden, the unnecessary destruction of the ancient monastery of Monte Cassino, and other acts inconsistent with the law of armed conflict. At the end of the war, the Soviets plundered over a million objects from Germany, claiming them as reparations and replacement for what they had lost.[17]

Since the Second World War, hundreds of claims have been made before national and international courts and tribunals to recover art, antiquities, and other valuables that changed hands during the long years of the conflict. These cases, especially the "Holocaust claims," have clearly strengthened the principle of repatriation found in the law of armed conflict.[18] Indeed, in a number of cases the courts seem to have ruled more on moral grounds than legal ones, resulting in a more expansive right of return.[19] Moral arguments are now standard in repatriation claims.[20]

15. J. H. Merryman and A. E. Elsen 2003, pp. 28–29.

16. International Military Tribunal 1948, pp. 279–82, 288–92, 293–98.

17. See, e.g., K. Akinsah et al. 1995.

18. A. F. Vrdoljak 2006, p. 3.

19. See J. Schachner Chanen 2006, p. 50, for a discussion of a number of these cases.

20. See K. A. Appiah 2006 for a discussion of how complex the moral claims are in these cases, regardless of how straightforward they may appear to claimants.

After the Second World War, the international community moved to strengthen the law of armed conflict by adopting the famous Geneva Conventions of 1949. While these afford greater protections for civilian property than prior law, another treaty was developed in 1954 to provide detailed protection for cultural property: the Hague Convention on the Protection of Cultural Property in Time of War. The United States has not yet become a party to the 1954 Convention out of concern that the Convention's balance is weighted too heavily toward protection. Still, the United States agrees that much of the Convention is customary international law, including the key provision in Article 4(3): "The High Contracting Parties further undertake to prohibit, prevent and, if necessary, put a stop to any form of theft, pillage or misappropriation of, and any acts of vandalism directed against, cultural property." In addition to the Hague Convention, important principles of customary international law have grown up to protect cultural property in time of war, in particular the principles of necessity and proportionality. The obligations to respect cultural property and to use only that force which is necessary and proportional are included in the 1977 Additional Protocols to the Geneva Conventions.

The 1977 Additional Protocols were adopted to cover the wars of national liberation that were leading, at that time, to the end of colonial empires. In 1979, Amadou-Mahatar M'bow, director-general of UNESCO, called on states to return cultural property as another aspect of ending the colonial era:

> I call on historians and educators to help others to understand the affliction a nation can suffer at the spoliation of the works it has created. The power of the *fait accompli* is a survival of barbaric times and a source of resentment and discord which prejudices the establishment of lasting peace and harmony between nations. . . .

> The return of a work of art or record to the country which created it enables a people to recover part of its identity, and

proves that the long dialogue between civilizations which shapes the history of the world is still continuing in an atmosphere of mutual respect between nations.[21]

Also in 1979, the Executive Committee of the International Council on Museums (ICOM) adopted the findings of the "Study on the Principles, Conditions, and Means for the Restitution or Return of Cultural Property in View of Reconstituting Dispersed Heritages," which concluded with the following statement:

> The reassembly of dispersed heritage through restitution or return of objects which are of major importance for the cultural identity and history of countries having been deprived thereof, is now considered to be an ethical principal recognized by the major international organizations. This principle will soon become an element of *jus cogens* of international relations.[22]

The 1998 Rome Statute of the International Criminal Court includes intentional destruction of cultural property as a war crime in Article 8(2). Nevertheless, it would be difficult to conclude that restitution or repatriation had become a *jus cogens* or peremptory norm of international law by 2002. Return was clearly a well-established principle, however—much as Professor Merryman predicted.

Return in Decline?

Despite eloquent and impassioned arguments by museum directors and others,[23] the return principle may well have achieved the status of *jus cogens* had it not been for the Iraq invasion of March 19, 2003.

21. A.-M. M'Bow 1979, pp. 58ff.

22. See J. A. Cohan 2004, p. 83 (quoting J. A. R. Nafziger 1983, pp. 789, 804).

23. D. Rudenstine 2001, pp. 69, 70–71.

This section reviews events in Iraq from March 2003 to March 2007 that are most relevant to the principle of return.

It was clear very soon after the invasion began that U.S. and British soldiers had not been given orders consistent with the obligation to protect cultural property in time of war. In the absence of protection, widespread looting and chaos erupted. According to the *San Diego Union Tribune*, "Though Pentagon officials were warned as early as January 2003, and repeatedly since, that a US invasion would place cultural treasure in grave danger, and though international law mandates the protection of artistic treasures in times of war, Defense Secretary Donald Rumsfeld made the point again and again that soldiers were not there to stop plunder."[24] It was in connection with the looting and plunder that Secretary Rumsfeld made his now famous comment, "Freedom's untidy. And free people are free to make mistakes and commit crimes and do bad things."[25] Rumsfeld dismissed concerns over the looting of museums and archeological sites with the comment: "[I]t's the same picture of some person walking out of some building with a vase, and you see it 20 times and you think, 'My goodness, were there that many vases? Is it possible there were that many vases in the whole country?'"[26]

The Hague Regulations, however, state unequivocally that people are not free to commit crimes. It is the duty of the occupying power to stop them. Nor may the occupying power claim excuses such as military necessity for failing to protect cultural property from looting and theft during an occupation. The failure to give the proper orders may have been related to the desire to keep costs low—protecting cultural property would have required thousands more troops. The failure may also be related to a contempt for international law.

24. J. de Poyen 2003.
25. J. Brinkley 2003.
26. Voice of America Press Releases and Documents 2003; see also L. Diebel 2003.

As a result of invading on the cheap and dismissing legal obligations, the United States had neither a large enough force nor obviously a force with the right orders to fulfill its Hague Regulation, the 1954 Hague Convention, the Geneva Convention, or customary international law duties. U.S. officials dismissed the outcry over the looting of the Iraqi National Museum because the director misstated the number of objects lost. He gave numbers as high as 170,000. The U.S. State Department estimated it was closer to 13,400. The losses were still huge, but more easily ignored. Worse in many ways than the looting of museums and libraries was the total lack of security around archeological sites:

> The extent of illicit excavation in Iraq today is unprecedented. Iraqi archaeologists and the CPA [Coalition Provisional Authority] ministry of culture report that in the last 10 months [April 2003–February 2004] the destruction at archaeological sites has reached a previously unimagined level. . . . Without the guards at ancient sites and police at border points in the country, Iraqi cultural heritage will continue to be plundered.[27]

Looting was continuing unabated as of March 2007, with few objects being returned.[28] Indeed, only the Entemena statue[29] and a few other important pieces had been recovered four years after the invasion.[30]

The election of a Shiite-dominated government in Iraq in 2006 further complicated the issue of repatriation. The "radical Shiite cleric Moktada al-Sadr, who commands his own militia, emerged with enough seats in Parliament to take control of four ministries and to create a Ministry of Tourism and Antiquities"[31] with the

27. Z. Bahrani 2004; see also M. Gottlieb 2003.
28. FBI Publication 2007. See also P. Gerstenblith in this volume.
29. U.S. Department of State Press Release 2006.
30. G. Gugliotta 2003. See also M. D. Lemonick 2003.
31. M. Garen and M.-H. Carleton 2006.

responsibility for protection of cultural heritage. Donny George, long-time chairman of the Iraqi State Board of Antiquities and Heritage, a body charged with protecting the nation's antiquities since 1923, fled in 2006. The Ministry of Tourism and Antiquities' personnel who succeeded George lacked his administration's expertise. They were also allies of al-Sadr. The al-Sadr movement has been associated with the 2004 burning and looting of the Nasiriyah Museum by radical Shiite militants.[32] Moreover, "[t]he center for Iraq's illicit antiquities trade, Fajr, in the heart of the Sumerian plain, is also a stronghold for militants loyal to Mr. Sadr."[33] A link between Islamic militants and looting at sites rich with pre-Islamic antiquities has not been proven at time of writing, but the possibility alone has been sufficient to cause scholars to voice concern over the future of Iraq's national treasures.

Scholars have indicated that the replacement of George and many of his former colleagues with "religiously conservative Shiite Muslims throughout Iraq's traditionally secular archaeological institutions could threaten the preservation of the country's pre-Islamic history."[34] The concern has been expressed that the post-invasion ministry is only focused on protecting Islamic sites and artifacts, "turning a blind-eye to pre-Islamic ones."[35] "Looting in the southern Dhi Qar Governorate, an area rich in pre-Islamic sites, has been increasing. [Additionally,] [t]wo pre-Islamic statues were returned to the National Museum with a note attached to them referring to the pieces as 'idols.'"[36] In the 2004 looting of the Al-Nasiriyah Museum, "which contained a huge collection of Sumerian, Assyrian, Babylonian, and Abbasid artifacts," the museum's guards stated that the militants promised to do to the antiquities "what the Taliban did"—"an apparent reference to the Taliban's 2001 destruction of the Bamyan Buddha statues in Afghanistan on

32. Ibid.
33. Ibid.
34. Ibid.
35. SperoNews 2006.
36. Ibid.

the grounds they were idolatrous."[37] Elizabeth Stone, an anthropologist at New York's Stony Brook University, has observed that "[w]hat is striking is that the Islamic parts are left alone, whereas the immediate pre-Islamic sites are not." She has heard rumors that "Islamic militants were looting artifacts and selling them to fund their activities."[38]

Despite these concerns regarding the safety and wisdom of returning objects to Iraq, the United States and the international art community continued to work to return looted objects. By 2007 the question had become whether return was the governing legal principle. Obviously, it makes no sense to attempt to return objects where it is simply too dangerous to enter the country. A thousand people alone died in Iraq between January 26 and February 6, 2007. The danger inherent in returning ancient objects in such a situation is plain.[39]

Even when order is eventually restored, however, if Iraq's government shares the view that pre-Islamic art is idolatrous, what does international law require then? Throughout the history of law on cultural property, the first principle has been protection, the next principle, return. Museums have consistently argued against return where objects might not receive proper care. The value of protection has been raised in response to appeals to display objects in context, meaning close to the places where they were created. Museum directors in the West have argued they have the greater

37. Ibid. The Bamyan Buddhas were destroyed after they were declared "idolatrous and against the tenets of Islam" by the Taliban. See also CNN World News 2001. Additionally, "[a]n estimated 6,000 [pre-Islamic] statues were housed in the Kabul Museum. It is believed most have been destroyed, although the Taliban have refused to allow anyone inside the war-ravaged building" (CNN World News 2001). See also P. Gerstenblith 2006, p. 245.

38. Stone, quoted in SperoNews 2006.

39. International law provides defenses such as duress and necessity to justify failing to fulfill an obligation like the duty of return if doing so will put persons at serious risk of their lives.

ability to protect ancient objects from the elements, pollution, and mishandling.[40] These arguments have often been dismissed as patronizing. Yet it may be time to reconsider the protection principle. During armed conflict, the obligation to protect cultural heritage from looting and intentional destruction is paramount. We may need to expand the protection principle beyond protection from targeting in armed conflict. Certainly, returning objects during an armed conflict should not be required. Protecting objects from those hostile to the culture that created them is also consistent with the protection principle. Extending the principle to situations beyond protecting objects from destruction to ensuring they are made accessible also fits.[41]

The Entemena statue looted from the Iraqi National Museum was recovered in 2006. It is not in a museum today but rather in an office of the Iraqi embassy in Washington.[42] So while it is being protected from destruction, it is hidden from the public. The United States and Iraq should have agreed to display the statue in a "museum-in-exile" or similar arrangement, as was done for Afghan objects. More than 1400 objects were kept safe from the Taliban and war while on public display in Switzerland.[43]

Conclusion

Since the Versailles Treaty, international law has required the return of objects looted in war. This requirement of return grew with the end of colonial empires. By 2003, return had become not just a legal

40. See the chapters by J. Cuno, J. H. Merryman, and S. Urice in J. H. Merryman 2006.

41. Protecting accessibility may have implications for the right of wealthy individuals to acquire publicly-held objects. See, e.g., M. Kimmelman 2006.

42. B. Meier and J. Glanz 2006; T. McCarthy 2006.

43. *N.Y. Times* 2007.

but a moral principle. States demanded the return of objects to the places where they were created. But just as the principle of return appeared set to gain the status of a peremptory norm, the United States led a small coalition in the invasion of Iraq. Four years after the invasion began there is a new discussion underway regarding return. Surely the protection principle prohibits returning objects to a war zone, but the need to protect has implications for return in situations other than armed conflict. Cultural property may need protection from those who would destroy or deny public access to important objects. Thus, as important as return is, it might be time to re-think it in order to achieve a better balance with other valued principles, such as protection.

Bibliography

Books

Akinsah, K., et al. 1995. *Beautiful Loot: The Soviet Plunder of Europe's Art Treasures.* New York.

Conklin, J. E. 1994. *Art Crime.* Westport, CT.

Darraby, J. L. 2006. *Art, Artifact and Architecture Law.* Eagan, MN.

Dolnick, E. 2005. *The Rescue Artist: A True Story of Art, Thieves, and the Hunt for a Missing Masterpiece.* New York.

Fleck, D., ed. 1995. *The Handbook of Humanitarian Law in Armed Conflict.* New York.

Gazzini, I. F. 2004. *Cultural Property Disputes: The Role of Arbitration in Resolving Non-Contractual Disputes.* New York.

Gerstenblith, P. 2004. *Art, Cultural Heritage, and the Law: Cases and Materials.* Durham, NC.

Houpt, S. 2006. *Museum of the Missing: A History of Art Theft.* New York.

Kowalski, W. A. 1998. *Art Treasures and War: A Study on the Restitution of Looted Cultural Property, Pursuant to Public International Law,* T. Schadla-Hall, ed. London.

Merryman, J. H., ed. 2006. *Imperialism, Art and Restitution.* New York, Cambridge.

Merryman, J. H., and A. E. Elsen. 2003. *Law, Ethics, and the Visual Arts.* 4th edition. New York.

Middlemas, R. K. 1975. *The Double Market: Art Theft and Art Thieves*. Farnborough, England.

Scafidi, S. 2005. *Who Owns Culture? Appropriation and Authenticity in American Law*. New Brunswick, NJ.

Toman, J. 1996. *The Protection of Cultural Property in the Event of Armed Conflict*. Brookfield, VT.

de Vattel, E. 1916. *The Law of Nations or the Principles of Natural Law, Applied to the Conduct and to the Affairs of Nations and of Sovereigns*. Trans. C. G. Fenwick from 1758 edition. Washington, DC.

Vrdoljak, A. F. 2006. *International Law, Museums and Return of Cultural Property*. New York.

Journals

Appiah, K. A. 2006. "Whose Culture Is It?" *N.Y. Rev. Books*, February 9, pp. 38–41.

Chang, D. N. 2006. "Stealing Beauty: Stopping the Madness of Illicit Art Trafficking." *Hous. J. Int'l L.* 28, pp. 829–69.

Checkland, S. 2000. "Stealing the Show." *New Statesman*, December 18, pp. 46–47.

Cohan, J. A. 2004. "An Examination of Archaeological Ethics and the Repatriation Movement Respecting Cultural Property (Part Two)." *Environs Envtl L & Pol'y J.* 28, pp. 1–115.

George, T. E. 2005. "Using Customary International Law to Defend "Fetishistic" Claims to Cultural Property." *N.Y.U. L. Rev.* 80, pp. 1207–36.

Gerstenblith, P. 2006. "From Bamiyan to Baghdad: Warfare and the Preservation of Cultural Heritage at the Beginning of the 21st Century." *Geo. J. Int'l L.* 37, pp. 245–351.

Hughes, J. 2000. "The Trend toward Liberal Enforcement of Repatriation Claims in Cultural Property Disputes." *Geo. Wash. Int'l L. Rev.* 33, pp. 131–53.

International Council of Museums. 1979. "Study of the Principles, Conditions and Means for the Restitution or Return of Cultural Property in View of Reconstituting Dispersed Heritages." *Museum* 31, pp. 62ff.

Kirshner, J. R. 1982. "Thieves Like Us and Art Robberies." *Artforum*, pp. 40–42.

Lemonick, M. D. 2003. "Lost to the Ages." *Time*, April 28. Available at http://www.time.com/time/magazine/article/0,9171,1004726,00.html.

M'Bow, A.-M. 1979. "A Plea for the Return of Irreplaceable Cultural Heritage to Those Who Created It." *Museum* 31, pp. 58–61.

McQuillan, D. 1995. "Adventures of a Mobile Masterpiece: One of Vermeer's Most Famous Paintings has Been Twice Stolen—and Twice Restored—Jan Vermeer's 'Lady Writing a Letter with Her Maid.'" *Insight on the News*, November 20. Available at http://findarticles.com/p/articles/mi_m1571/is_n44_v11/ai_17611800.

Merryman, J. H. 1986. "Two Ways of Thinking about Cultural Property." *Am. J. Int'l L.* 80, pp. 831–53.

Moustakas, J. 1989. "Group Rights in Cultural Property: Justifying Strict Inalienability." *Cornell L. Rev.* 74, pp. 1179–1227.

Nafziger, J. A. R. 1983. "The New International Framework for the Return, Restitution or Forfeiture of Cultural Property." *NYU J. Int'l L. & Pol.* 15, pp. 789–812.

O'Connell, M. E. 2004. "Occupation Failures and the Legality of Armed Conflict: The Case of Iraqi Cultural Property." *Art, Antiquity and Law* 9, pp. 323–62.

Radin, M. J. 1982. "Property and Personhood." *Stan. L. Rev.* 34, pp. 957–1015.

Rudenstine, D. 2001. "Cultural Property: The Hard Question of Repatriation." *Condozo Arts & Ent. L. J.* 19, pp. 69–104.

Schachner Chanen, J. 2006. "Art Attack." *A.B.A. J.* 92, December, pp. 50–56.

Shillingford, D. 2005. "The Art of the Steal." *Foreign Policy*, March–April, pp. 28–30.

Thomas, K. D. 2006. "To Catch Art Thieves." *ARTnews* 105(5), May, pp. 154–55.

Newspapers

Associated Press. 2006. "Parthenon Piece Returned." *The Australian*, August 25, World 9.

Bahrani, Z. 2004. "In the Fray: British and Swiss Get Tough about Smuggling." *Wall St. J.*, February 18, D4.

Blair, D. 2002. "Iraq Seeks to Restore Glories of Babylon." *London Telegraph*, May 4. Available at http://www.telegraph.co.uk/news/main.jhtml?xml=/news/2002/05/04/wiraq04.xml.

Boehm, M. 2006. "Germany to Return Artifacts." *Los Angeles Times*, May 26, E2.

Brinkley, J. 2003. "Rumsfeld Defends Rebuilding of Iraq." *Int'l Herald Trib.*, May 28, p. 5.

Cooper, H., and D. E. Sanger. 2007. "Iraqi Progress Misses Targets in Bush's Plan." *N.Y. Times*, March 15, A1.

Diebel, L. 2003. "Rumsfeld on Chaos in Iraq: 'Stuff Happens,' U.S. Defence Secretary Shrugs It Off, Red Cross Says Order Must Be Restored." *Toronto Star*, April 12, A08.

Fielding, F. 2002. "Museums Unite against Return of Imperial 'Loot.'" *The Sunday Times*, December 8, p. 19.

Frammolino, R., and J. Felch. 2006. "Getty Makes New Offer to Italy." *Los Angeles Times*, November 22, p. 1.

Garen, M., and M.-H. Carleton. 2006. "New Concern over Fate of Iraqi Antiquities." *N.Y. Times*, September 9, B7.

Gettleman, J. 2006. "Unesco Intends to Put the Magic Back in Babylon." *International Herald Tribune*, April 21. Available at http://www.iht.com/articles/2006/04/13/news/babylon.php.

Gottlieb, M. 2003. "Looters Swarm over Remote Sites, Study Finds." *N.Y. Times*, June 12, A14.

Gugliotta, G. 2003. "Scholars Fret about Fate of Antiquities after War." *Milwaukee J. and Sentinel*, March 17, 05G.

Kimmelman, M. 2006. "Klimts Go to Market; Museums Hold Their Breath." *N.Y. Times*, September 19, B1.

MacAskill, E. 2002. "Iraq Appeals to Berlin for Return of Babylon Gate." *The London Guardian*, May 4. Available at http://www.guardian.co.uk/Iraq/Story/0,2763,709809,00.html.

McIver, B. 2004. "Raiders of the Lost Art: It's Enough to Make You Scream. The Seemingly Glam World of Art Theft Is Really Full of Mindless Thugs." *Glasgow Daily Record*, August 24, p. 20.

Meier, B., and J. Glanz. 2006. "Piece from Looted Museum Returned/Headless Statue Had Been Taken to Syria, Put on Sale on International Antiquities Market." *Houston Chronicle*, July 30, A25.

N.Y. Times. 2007. "Exile Ends for Afghan Art." March 19, B2.

de Poyen, J. 2003. "Looting of Iraqi Museum Was a Blow to All Peoples." *San Diego Union-Trib.*, April 20, F-8.

Miscellaneous

A&E Television Broadcast. 1997. *Crimes in Time.*

BBC News. 2005. "Who Should Own Historic Artifacts?" April 26. Available at http://news.bbc.co.uk/2/hi//talking_point/4460037.stm.

Die Bundesregierung Press Release. 2006. "German Government for Protection of Cultural Diversity." September 27. Available at http://www.

bundesregierung.de/nn_6562/Content/EN/Artikel/2006/09/2006-09-27-schutz-kultureller-vielfalt__en.html.

CNN World News. 2001. "World Appeals to Taliban to Stop Destroying Statues." March 3. Available at http://archives.cnn.com/2001/WORLD//asiapcf/central/03/03/afghan.buddhas.03/index.html.

European Convention. 1969. "European Convention on the Protection of the Archaeological Heritage." *CETS* no. 066, May 5. Available at http://conventions.coe.int/Treaty/en/Treaties/Html/066.htm.

———. 1992. "European Convention on the Protection of the Archaeological Heritage (Revised)." *CETS* no. 143, January 16. Available at http://conventions.coe.int/Treaty/en/Treaties/Html/143.htm.

FBI Publication. 2007. "Top Ten Art Crimes: Art Crime Team, Iraqi Looted and Stolen Artifacts." Available at http://www.fbi.gov/hq/cid/arttheft/topten/iraqi.htm. Accessed June 14, 2007.

Gibson, M. "Cultural Tragedy in Iraq: A Report on the Looting of Museums, Archives, and Sites." *IFAR*. Available at http://www.ifar.org/tragedy.htm.

Hague Convention IV. 1907. "Articles 245 and 246." October 18.

International Audit Commission. 2004. "Report on Babylon: Current Condition." December 11–13. Available at http://www.mfa.gov.pl/BABILON,REPORT,2200.html. (Section V, Ishtar Gate Review).

International Military Tribunal. 1948. "Trial of Major War Criminals."

Marzahn, J. 1995. "The Ishtar Gate," "The Processional Way," "The New Year Festival of Babylon." Museum Catalogue. Staatliche Museen zu Berlin, Vorderasiatisches Museum. Berlin.

McCarthy, T. 2006. "Looted Statue Returned to Iraq but Won't See the Light for Some Time." *ABC News*. August 7. Available at http://abcnews.go.com/International/IraqCoverage/story?id=2282183&page=1.

Muller-Karpe, M. 2004. *50 Years Hague Convention*. (Public address). Vienna. Available at http://savingantiquities.org/pdf/MMKWien2004.pdf.

Nafziger, J. A. R. "Protection of Cultural Heritage in Time of War and Its Aftermath." *International Foundation for Art Research*. Available at http://www.ifar.org/heritage.htm.

Nasrawi, S. 2007. "Egypt Seeks Loans of Overseas Artifacts." *Yahoo! News*. April 29. Available at http://news.yahoo.com/s/ap/20070429/ap_on_en_ot/egypt_antiquities;_ylt=An7IzYv3ck2rEdkFIzQEyakDW7oF.

Paley, S. M. "Nimrud, the War and the Antiquities Markets." International Foundation for Art Research. Available at http://www.ifar.org/nimrud.htm.

SperoNews. 2006. "Iraq: Antiquities Still Pillaged and Destroyed." October 12. Available at http://www.speroforum.com/site/article.asp?id=6043.

UNESCO Convention. 1970. "Convention on the Means of Prohibiting and Preventing the Illicit Import, Export and Transfer of Ownership of Cultural Property." *ILM* 9, November, p. 1031. Available at http://www.unesco.org/culture/laws/1970/html_eng/page1.shtml.

UNIDROIT Convention. 1998. "Convention on Stolen or Illegally Exported Cultural Objects." January 7. Available at http://www.unidroit.org/english/conventions/1995culturalproperty/1995culturalproperty-e.htm.

UNIDROIT.org. Available at http://www.unidroit.org/english/implement/i-95.pdf.

U.S. Department of State Press Release. 2006. "U.S. Repatriates Historical Artifact to the Iraqi People." July 25. Available at http://www.state.gov/r/pa/prs/ps/2006/69504.htm.

de Visscher, C. 1949. "International Protection of Works of Art and Historic Monuments." *U.S. Department of State, Documents and State Papers.*

Voice of America Press Releases and Documents. 2003. April 12. Available at 2003 WL 17342366.

Response to Mary Ellen O'Connell

Charles K. Williams II .

THE O'CONNELL PAPER IS CERTAINLY A CLEAR AND impartial presentation of the complicated facts of international law surrounding the "repatriation" of national treasures to their land of origin. Should, however, the land of origin necessarily be the most dominant or determinant factor here? As pointed out by O'Connell, some lands of origin have gone through great historical, religious, and philosophical changes since the artifacts were created; now many of the people in those lands are no longer ancestors of the people who created the objects, nor are they philosophically attuned to them. In responding, I would like to broach some philosophical questions that stand, perhaps, outside the definition of law as strictly applied. Perhaps there is more to the problem facing us than repatriation of objects to their country of origin. In this respect, is the issue of nationalism vs. globalization perhaps worth a look? Putting laws of ownership aside for the moment, is there value in considering our subject in the light of present trends toward world trade, global communication, and international economics?

In a perfect world where all cultural objects would be available to everyone, where no local wars would limit or cancel travel, and where no Iron Curtains would close off the view, a country might have a right to develop a monopoly of its own great art or cultural

artifacts, that is, as long as the cultural objects were kept available to the rest of the world. If, however, cultural artifacts are in danger of being destroyed for ideological reasons, should not the principle of "safe havens" come into play, or at least be seriously considered? (See *Art and Archaeology in Afghanistan: Its Fall and Survival. A Multi-disciplinary Approach*, edited by J. van Krieken Peters, Leiden, 2006). If a specific country and its cultural objects become sealed off from the rest of the world, is there not reason to have a reservoir elsewhere to help teach and inspire? How much, for example, did Russian control of Ukranian archaeology during the years of the Iron Curtain hold back international research on the Scythians?

Let us consider the Elgin Marbles. Their presence in the British Museum was a driving force for a Greek revival in London and resulted, among other things, in the many Erechtheion details found today on numerous churches in London, for instance, St. Eustace. The focused interest in Classical Greek culture in England is largely why London's Classical Revival architecture is so much more delicate than the Classical Revival in Paris, which itself is derived from the French Academy through Rome, not Greece. The Erechtheion stood as a standard for Greek Revival Architecture in England and provided London with an architectural flavor decidedly different from that of Paris. Would this have happened if there had not been a physical presence in London of the antiquities themselves, available to British architects?

In the past, architectural and sculptural styles were most effectively transmitted through the physical object. The Romans from Augustus onward were Hellenized by booty; Venice was transformed by Crusader booty from Constantinople. Today the world is much more sophisticated, and there are much easier ways to transmit ideas than by looting. It remains, nonetheless, hard to impart the power of a far-distant or unknown culture without the physical objects themselves to appreciate, no matter how real virtual reality is or may become.

A corollary to the principle of the magnetism of the object is, I think, that when an area or state achieves a monopoly of its

antiquities or culture, it eventually will isolate its heritage from the world cultural community. How can young people of the Western world become excited about far-away cultures or even want to learn about them if the culture is not made somehow immediate? The physical objects that are so readily available in the everyday world entice the mind at every turn and are a very effective way to make the unknown or relatively unknown attractive. Note that modern mythology is being manufactured at such a rate and in such quantity in the United States and northern Europe that it appears, at least to me, to be wiping out the need or desire to know, even less to understand, ancient epics, myths, and fables. We who are interested in ancient history and culture and find it worth preserving should be worrying about this. Harry Potter is better known in England and the United States than Odysseus or Ulysses; Rudolph the Red-Nosed Reindeer is a more vivid image in the States than Heracles and his feats. Objects grab the attention. The popularity of a blockbuster such as the Tutankhamen Exhibit—not owned by the museums it is shown in, just traveling the United States—shows how effective the physical object is and what a draw an object-focused exhibition can be.

If economic and philosophical goals become more and more a global focus, should not culture keep pace? Looting of objects and illicit trade in them definitely is not the road to take, but general exchange of the world's important icons must be made freer, more general, and, ultimately, obligatory.[1] Unless the antiquities-rich nations go global with their cultural objects, either by flooding the world with exhibitions or by sharing museum basement material, I don't think that there is any way of turning off or diminishing the buyer's appetite for the strange, the beautiful, and the far-away when illicit objects come to the marketplace.

1. The Italian Government already has in place the policy that museum storeroom material, whole grave groups, or the like can be loaned for display to foreign museums upon application. I thank S. Vassallo for this information; Syria apparently operates by this same principle.

Finally, a major problem lies in the focus of the nations that determine the world's future, who seem to think as little as possible about cultural objects and their value and even less about their cultural significance and context. The most recent examples of this attitude are the United States in its recent invasion of Iraq, during which acceptable precautions to protect the national heritage were not taken, and the Taliban, which destroyed non-Muslim culture in Afghanistan, including the sixth-century Buddhas in the Bamiyan Valley. Is globalizing artifacts by extended leases or loans—thereby sharing more broadly both cultures and objects—not a possible means of ensuring the world heritage for the future? Should a model of globalization be considered for antiquities?

The Corinth Theft

Nancy Bookidis

DURING THE NIGHT OF APRIL 12, 1990, GOOD Thursday in the Greek Orthodox Easter Calendar, thieves broke into the Corinth Archaeological Museum in Greece and carried off more than 270 objects. When the American School of Classical Studies in Athens built the museum in 1932, the likelihood of theft was relatively slight, and the safety measures taken then were thought to be sufficient: heavy bronze doors, thick walls of solid concrete, and windows divided into slats that were too narrow for passage. At the same time, the building's design reflected a spirit of openness, for the galleries and workrooms were designed around two large courts, open to the sky—one for the public, one for the staff. This proved to be our undoing.

After beating and tying up the night guard, the thieves tried to force the bronze doors, but a 1932 Yale lock could not be broken. They then climbed over the outer roof into the main courtyard.[1] From there they easily broke through the glass doors and entered the galleries. Beginning with the Greek gallery, they systematically

1. They had, apparently, "cased" the museum as tourists and had bought ladders in nearby New Corinth just in case they couldn't force the door.

pried open the cases and emptied them, leaving behind whatever they thought would not "sell," more Corinthian than Attic pottery, as it turned out. They then proceeded to the Roman gallery. Fortunately, time ran out before they could empty this one as well. Fortunately, too, they could not take large objects because they had to lift everything over the roof. This process of transportation led to some damage, in particular to the hair and nose of a marble head of Dionysos.[2]

Once the police arrived, the museum was blocked off, and we could only look in through the windows. What we could see was devastating: endless empty cases with their doors hanging open. One fine Attic black-figure cup[3] had accidentally been left on a stone funeral couch in the center of the room, for the thieves had, of course, functioned in the dark. Still, I cannot begin to describe how we felt as we looked through those windows, and afterwards when we could enter the museum—the violence of the act, the looting of what had become old friends and treasured monuments of Corinthian history. In a Greek documentary on antiquity theft, *The Network*, I used the word "rape." In fact, Corinth had been raped.

They had taken 15 fragments of marble statues, chiefly Roman heads but also one early fifth-century BCE head; 5 large-scale terracotta heads of the sixth, early fifth, and fourth centuries BCE— the best of our collection; 159 vases; 51 figurines; 11 glass vessels; 28 pieces of jewelry and small utensils; and one bronze statuette.[4]

I would like to describe what work that theft generated. This is not often considered in the aftermath of a theft. We were in the middle of our annual training excavations for the students of the

2. S-1669: International Foundation for Art Research (IFAR), *IFAR Reports* 1990, no. 685; F.-J. de Waele 1961, p. 190 for photograph. On the whole, damage to the objects was slight.

3. CP-552. J. D. Beazley 1956, p. 52.13; H. A. G. Brijder 1983, pp. 162, 248, no. 128, pls. 27b–c, 29b.

4. For a complete listing, see *IFAR Reports* 11.6, June 1990. The black-figure vases are shown in A. Brownlee 1995, pp. 337–82, pls. 91–96.

American School. We sent the students to Athens for a longer Easter break. Charles Williams II, the director, and I then began a case by case inventory of what was missing. As we completed each case, we passed the inventory numbers over to Robin Rhodes, who was working in Corinth. He pulled the inventory cards, which contained descriptions, dimensions, publication references, and small contact photographs, and handed them over to the two local representatives of the Greek Archaeological Service, who had to translate over 270 descriptions from English to Greek. We all started around 10:00 a.m. and had completed the inventory and translations by 7:00 p.m. of that same day. These were immediately given to the police.

Photographs were required; hundreds of negatives were sent up to our Athenian contract photographers, Ino Ioannidou and Lenio Bartziotou. Declaring a state of emergency, they closed their office to all business and printed some 1800 photographs within two weeks—six copies for the various ministry and police departments, the cost born by the American School. The American School also subsidized an issue of *IFAR Reports*, the report of the International Foundation for Art Research in New York, which appeared in June just two months after the theft. For this publication I had to provide compressed descriptions of all of the objects. Meanwhile, we had an excavation to carry on, students to train, and we were faced with a largely empty museum. The Archaeological Service gave us one month in which to set up new displays from our storerooms, which Mr. Williams and I slowly did when he could be freed from his work on the excavation. This required new inventory lists of the cases, additional photography, etc. Once this was finished, we could only sit and wait.

The Corinth theft was not a unique event, although it was the largest theft that had ever occurred in Greece. In the six months prior to ours, there had been 231 museum thefts in Greece, chiefly in smaller provincial collections. Like the Corinth Museum, these buildings had not been designed for maximum security; but unlike Corinth, many of the collections were not well documented or well

published. Everything that had been on display in the Corinth Museum had been catalogued and photographed,.and nearly everything had been published somewhere at some time, a fact that greatly helped in their recovery.

Thanks to the Corinth theft, the Greek government more energetically improved security in its collections. The American School paid for the installation of alarm and camera systems in all four museums built by American excavations: Corinth, Isthmia, Nemea, and the Athenian Agora. The Greek government installed systems elsewhere. Although these did not completely deter subsequent thefts, the number dropped dramatically.

In September of 1990, the first commercial article on the theft appeared in the art journal *Minerva*, published by the antiquity dealer, Jerome Eisenberg.[5] There, those wishing for more information were urged to consult the *IFAR Reports* for a complete listing of the objects.

The laws regarding the theft of antiquities have generally favored collectors, museums, and thieves. Each country has a different statute of limitations on just how long an object is considered "stolen." Proving ownership is also not always enough. A few years after the Corinth theft, a judge in Northern Europe awarded a stolen object to its new, "good faith" purchasers on the grounds that the original owner had not shown due diligence in its recovery. What constitutes "due diligence" is a matter of question.[6] Although many people told me about it, no one could tell me what must be done. Added to this was the official Greek attitude of extreme embarrassment about theft and a reluctance to publicize it. In Corinth, for example, we were not permitted to present any discussion or description of the theft to museum visitors. This meant that visitors, too, remained uneducated as to what the theft had cost them in terms of objects no longer on view.

5. S. Aspropoulos 1990.

6. The laws of Europe and the United States differ, as is shown in the article by P. Gerstenblith in this volume.

Although as foreign excavators, we were not technically or legally responsible for the objects, it was in our interest to continue publicizing the theft, which we did on occasion in the newspapers or in various journals. For obvious reasons, too, the police could not inform us of the progress of their work, despite the fact that within three years of the theft they were fairly certain of the perpetrators' identities, though they lacked definitive proof. These proved to be members of a Greek family named Karachalios who lived down the coast, apparently known specialists in antiquity theft and drugs. It seems that they had "offices" in Miami and South America. They had smuggled the Corinth material into Miami, Florida, in crates of fish.

Finding themselves unable to sell the objects and pretending to be innocent collectors, the Karachalioi offered to turn over the objects to the Greek police through a middleman for $1,000,000. In the meantime, however, a few objects began to surface on the art market: a Boeotian black-figure skyphos appeared in a sale catalogue of the Royal Athena Gallery, belonging to Jerome Eisenberg, publisher of *Minerva*. It was recognized by Dr. Ann Brownlee of the University Museum of the University of Pennsylvania, who had published the Attic black-figure pottery of Corinth.[7] She contacted Charles Williams, who in turn notified Interpol. In his sale catalogue, Eisenberg, however, had reproduced Side B of the vase, not the side that appeared in our IFAR catalogue. The latter was the only photograph of the piece in our files. Although the two sides are only slightly different,[8] the differences meant that the police could not be certain of the vase's identification. Therefore, pretending to be an interested buyer, Brownlee requested photographs. With these the police verified that it was indeed one of the stolen vases. When Eisenberg was approached by the police, he turned over

7. CP-2071: *IFAR Reports* 1990, no. 784: A. Brownlee 1995, pl. 94.

8. The vase is decorated with two nearly identical scenes of heraldic lions flanking a boar; they differ only in the position of a single lion's forepaw on each face.

several more vases that had come with it but expressed ignorance of their stolen source. Curiously, he had not checked their provenance with IFAR, as had been recommended in his *Minerva* article, but with London, where we were not listed.

The police and agents of the FBI were taken to a warehouse in Miami by the "representative" of the thieves, and the cases were recovered. When an inventory was made, fourteen objects were still missing, including three marble heads: Julius Caesar, the founder of Roman Corinth;[9] Eros;[10] and Serapis (fig. 1).[11] Not long after this discovery, Charles Williams attended an auction at Christie's in New York. There, in the auction catalogue, he saw a photograph of the head of Serapis, and immediately questioned the auction authorities about it. They gave him no information about the source of the head but simply said that it had been removed from auction.[12] He then notified Interpol, and, not long after that, we read in the newspapers that the three heads had been recovered. Six objects were never found: four vases and two Archaic figurines.[13] Because they are not of great value, I suspect they never will be found.

Ultimately, the police arrested the two Karachalios sons, who received life sentences. Regrettably, the father escaped. Nevertheless, the sentence given to the sons was an important one. Until that time, sentences for antiquity theft had been light, but because the value of the stolen objects reached $1,000,000, the crime was taken

9. S-2771: *IFAR Reports* 1990, no. 682; C. De Grazia 1973, pp. 77–80, no. 7; A. Datsoulis-Stavrides 1970, pp. 109–10, fig. 1.

10. S-2388: *IFAR Reports* 1990, no. 686; C. H. Morgan II 1936, p. 466, fig. 1.

11. S-2387: *IFAR Reports* 1990, no. 687; C. H. Morgan II 1937, pp. 539–40, fig. 1; O. Broneer 1954, pp. 134, 137, pl. 44.2.

12. This head had had "conservation" work done to it. Although we had intentionally left marks of burning on the head's face as a testimony to its discovery in a destruction debris, some of the blackening had been removed, the nose filled out, and the head drilled for mounting in a base. Christie's assured us that they had not done this.

13. *IFAR Reports* 1990, nos. 709 (MF-11970), 729 (KT-12-12), 757 (T-1660), 809 (T-1816), 830 (C-1968-59B) and 945 (T-1987).

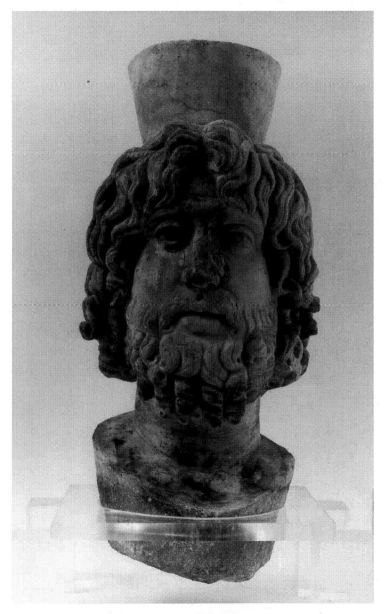

Figure 1. Marble head of Serapis, Roman. Courtesy of the Corinth Excavations, American School of Classical Studies at Athens.

to a higher court. Because both the theft and the court trial were highly publicized in Greece, the severity of the sentence may act as a deterrent to such acts in the future.

Of the objects stolen in the 232 thefts that occurred in Greece within a six-month period in 1989–1990, I believe that only the Corinth material has been recovered. The reasons are, I think, clear. First, the number of objects taken was very large. They were therefore difficult to disperse. Second, virtually all of the artifacts had been published at least once, and many of the pieces were very well known. Third, we publicized the theft as soon as possible and distributed photographs. Most important, the Greek police early on had a suspicion of the thieves' identities and, with the assistance of Interpol and the FBI, made the arrests.

But these successes do not wipe out the years of anxiety and discouragement we experienced. Some of the stolen objects were of considerable monetary value, but many were not. For example, the numerous, simple ivy and pattern Attic lekythoi that were stolen are commonplace.[14] But in a way, that is what made the theft even more incomprehensible and horrible. In their greed, the Karachalioi had robbed us of our past for comparatively small gain.

The history of a city is written from the ancient sources and from the objects found in situ as they had been left. From these we attempt to reconstruct not only the artistic history of the city but the character of its people as reflected in its customs. We archaeologists are often criticized for our emphasis on "context," that is, the specific find-place of an object. But contexts are important. Among the stolen and retrieved objects is a terracotta mask of Dionysos (fig. 2).[15] It is an unusual piece, for it depicts Dionysos with horns. How much would it have brought? I don't know, for it is heavily restored. In a museum or private collection it would be interesting as a curiosity. But its full import comes from its place of discovery

14. *IFAR Reports* 1990, nos. 805–7, 814–25; C. W. Blegen, R. S. Young, and H. Palmer 1964, graves 272, pl. 38, and 346, pl. 55, for example.

15. MF-1973-3: G. S. Merker 2000, pp. 77, 113, 332, 338, C273, pl. 22.

Figure 2. Terracotta mask of Dionysos, fourth century BCE. Courtesy of the Corinth Excavations, American School of Classical Studies at Athens.

in the Sanctuary of Demeter and Kore in Corinth. I excavated it in 1973 near a small theater that must have served for initiation rites of some sort.[16] Not only is it one of a very small number of artifacts that establish the presence of Dionysos in the Sanctuary cult, but its specific place of discovery near the theater also raises questions about ritual practices.

One of the finest pieces in the Corinth museum is a marble sphinx of the second quarter of the sixth century BCE,[17] which the thieves wanted to take but could not lift over the roof. It had been found in two pieces by two farmers—one collecting the head, the other the body. Apparently for nearly a year, they hid it in their homes while they received a steady stream of potential buyers. Unable to agree on a price, the farmers quarreled and ultimately turned the statue into the museum. Had this sphinx appeared in a museum with a label stating that it was "said to be from Corinth," I wouldn't have believed it. We have very little stone sculpture in Corinth before the Roman period, and that chiefly in limestone; terracotta was the preferred medium for large-scale statuary.[18] On his deathbed, one of the potential buyers revealed that the sphinx had been found in the vast North Cemetery that had been partially excavated by the American School in the 1920s.[19] Ironically, it is the only piece of sculpture to have been found there. Before the sphinx's discovery, conclusive evidence for Corinthian funerary sculpture was slight. Using the sphinx, however, we can begin to pull in other fragments to reconstruct a more accurate picture of Corinthian grave practices. To the Corinth sphinx we can add several lions in the Boston Museum of Fine Arts,[20] the Ny Carlsberg Glytothek,[21] and an un-

16. N. Bookidis and J. E. Fisher 1974, p. 290, pl. 59.

17. E. Walter-Karydi 1987, pp. 57–58, figs. 64–65.

18. J. C. Wright 1977; B. S. Ridgway 1981; N. Bookidis 1995.

19. For the cemetery, see C. W. Blegen, R. S. Young, and H. Palmer 1964.

20. M. B. Comstock and C. C. Vermeule 1976, pp. 9–10, no. 15 (97.289), from Perachora.

21. F. Poulsen 1951, pp. 23–24, nos. 5 (I.N. 1296) and 6 (I.N. 1297), from Loutraki.

published surface find from nearby Korakou—*disjecta membra* that are no longer just isolated pieces of sculpture but important testimonies to ancient Corinthian display.[22]

This year I suggested a dissertation topic to a graduate student at the American School in Athens, who is interested in trade between Greece and the West. I proposed that she examine the foreign find-places of Corinthian vases that have been attributed to specific painters or workshops in order to determine whether or not certain cities only bought from a limited group of artists. Ultimately, she gave it up—too many vases with unknown proveniences.

One might argue that our potential loss was not so great, for everything had been published. But anyone who has worked on objects knows that nothing can replace reexamination of a piece, even if it has been published a hundred times. In taking the four, large-scale terracotta heads of the sixth to early fifth centuries BCE, the thieves had effectively made it impossible to study Archaic and Early Classical sculpture at Corinth.[23]

In our case, the theft occurred in a museum with documented artifacts. This is no different, however, from the looting of sites with undocumented material that occurs daily wherever antiquities are to be found. So long as a market exists, people will steal. So long as dealers close their eyes to their sources, people will steal. How do we stop it, for we are all the victims when it happens?

22. Further evidence for Corinthian grave monuments can be found in a large base of limestone, which was excavated in the North Cemetery and which, apparently, once supported four stelai. It would be interesting to know whether the marble sphinx stood on one of them. For the base, see C. W. Blegen, R. S. Young, and H. Palmer 1964, pp. 66–68.

23. See S. S. Weinberg 1957 for terracotta sculpture at Corinth in general; for the heads, see pp. 307–8, nos. 10A (MF-1945A), 12 (MF-1944), pls. 66–67; pp. 317–18, no. 45A (MF-8631), pl. 73; C. K. Williams II and P. Russell 1981, pp. 31–33, no. 11 (SF-1980-1), pl. 9.

Bibliography

Aspropoulos, S. 1990. "Corinth Museum Looted." *Minerva* I.7, September, pp. 23–25.

Beazley, J. D. 1956. *Attic Black-figure Vase-painters.* Oxford, Princeton.

Blegen, C. W., R. S. Young, and H. Palmer. 1964. *Corinth XIII, The North Cemetery.* Princeton.

Bookidis, N. 1995. "Archaic Corinthian Sculpture: A Summary." In *Corinto e l'Occidente, Atti del trentaquattresimo convegno di studi sulla Magna Grecia* (Taranto, 7–11 October 1994), pp. 231–56.

Bookidis, N., and J. E. Fisher. 1974. "Sanctuary of Demeter and Kore on Acrocorinth: Preliminary Report V: 1971–1973." *Hesperia* 43, pp. 267–307.

Brijder, H. A. G. 1983. *Siana Cups and Komast Cups* I. Amsterdam.

Broneer, O. 1954. *Corinth* I. 4, *The South Stoa and Its Roman Successors.* Princeton.

Brownlee, A. 1995. "Attic Black Figure from Corinth: III." *Hesperia* 64, pp. 337–82.

Comstock, M. B., and C. Vermeule. 1976. *Sculpture in Stone: The Greek, Roman and Etruscan Collections of the Museum of Fine Arts, Boston.* Boston.

Datsoulis-Stavrides, A. 1970. "Tête de Jules César au Musée de Corinthe." *Athens Annals of Archaeology* 3, pp. 109–10.

de Grazia, C. 1973. "Excavations of the American School of Classical Studies at Corinth: The Roman Portrait Sculpture." Diss., Columbia University.

de Waele, F.-J. 1961. *Les antiquités de la Grèce: Corinthe et Saint Paul.* Paris.

IFAR (International Foundation for Art Research). 1990. *IFAR Reports* 11.6.

Merker, G. S. 2000. *Corinth* XVIII. 4, *The Sanctuary of Demeter and Kore: Terracotta Figurines of the Classical, Hellenistic, and Roman Periods.* Princeton.

Morgan, C. H., II. 1936. "Excavations at Corinth, 1935–1936." *AJA* 40, pp. 466-84.

―――. 1937. "Excavations at Corinth, 1936–1937." *AJA* 41, pp. 539–52.

Poulsen, F. 1951. *Catalogue of Ancient Sculpture in the Ny Carlsberg Glyptotek.* Copenhagen.

Ridgway, B. S. 1981. "Sculpture in Corinth." *Hesperia* 50, pp. 422–48.

Walter-Karydi, E. 1987. *Alt-Ägina* II, 2: *Die äginetische Bildhauerschule. Werke und schriftliche Quellen.* Mainz.

Weinberg, S. S. 1957. "Terracotta Sculpture at Corinth." *Hesperia* 46, pp. 289–319.

Williams, C. K., II, and P. Russell. 1981. "Corinth: Excavations of 1980." *Hesperia* 50, pp. 1–44.

Wright, J. C. 1977. "A Poros Sphinx from Corinth." *Hesperia* 46, pp. 245–54.

Response to Nancy Bookidis

Joanne M. Mack

NANCY BOOKIDIS USES THE THEFT AT THE CORINTH Archaeological Museum, a major art theft perpetrated by professional criminals, as an example of the effect of the illicit antiquities trade upon museums, art history, and archaeological research. Bookidis also illustrates what measures museums might put in place to increase the likelihood of recovery, as well as measures that might reduce the number of art thefts from museums and archaeological sites. But her main point is that the market for antiquities acts as a catalyst for theft from museums as well as from archaeological sites, galleries, and private collections. In addition, the theft at the Corinth Archaeological Museum had several costs— monetary, educational, and scholarly—which often go unrecognized when art theft is discussed. She notes that the difficulty of recovery for a museum or archaeological researcher is linked to the nature of the laws regarding the theft of antiquities and art, the type of thief involved, and the ethics of some art dealers, auction houses, and museum curators. What, then, are some steps to take in order to lessen the number of successful thefts from museums and archaeological sites? As an anthropological archaeologist who specializes in the cultures of North America, I may have a slightly different perspective than the other speakers and respondents at this sympo-

sium, but the problems we face are similar. Art and artifact theft is a global problem.

Significant Points

There are several steps which could lessen the number of thefts and increase the likelihood of recovery. First, we must recognize there is a problem. For example, of the known art thefts between 1983 and 1986, 11 percent were from museums throughout the world and 37 percent were from galleries.[1] Second, we must build cooperation between museums and archaeologists. As part of this cooperation, public notification is critically important: let the public know and understand what is at stake.[2] And don't let the media oversimplify the issue into a debate between museums and archaeologists, which weakens the potential to alert the public to the severity of the problem. Also do not allow the press to romanticize the thief. Let it be known that often the people involved in large thefts are also involved in drug trafficking and other major crime, such as funding insurgents throughout the world. They are dangerous people. Of course, art thefts are committed by opportunistic crooks or unethical employees, but large thefts, such as the one at Corinth, are often undertaken by cartels, which are involved in other illegal activities. Another aspect of notification is to publish information on all thefts fully in professional publications. Thefts should not be hidden because the museum or archaeological project is embarrassed and wishes to protect its reputation. The help of other professionals can increase the chance for stolen objects to be recovered, as illustrated by the recognition in two different instances of objects from the Corinth Archaeological Museum theft, which led to their recovery and return to the museum.

1. S. MacKenzie 2005.
2. G. Stuart 1999.

There are also actions which museums and archaeologists may take to decrease the ease with which thieves may steal from museums and archaeological excavations and laboratories and to increase the recovery rate for objects if stolen. They include developing and supporting help for smaller, regional museums by large museums, college and universities, foundations, and governments. In approximately the last ten years the theft of antiquities and art from small, regional museums has increased dramatically. In Greece, Bookidis notes that in the six months before the Corinth theft there had been 231 museum thefts in Greece. In the United States since the 1960s the number of small, regional museums has increased dramatically, so that by 1996 there were 7500.[3] Such museums have minimal funding and staff, often hiring one paid staff member and operating primarily with volunteers. Such museums are particularly vulnerable to theft. All museums can deter theft by the installation of better security, and they will increase the chances for recovery if they have complete inventories with photographs and have published information on their collections, with specific research articles on objects. However, smaller museums and galleries lack sufficient funds for security, thus making them vulnerable. They also lack the professional staff for publications based upon their collections, and even for completing inventories of their collections. Without help such small museums will never be able to afford the time or the money to implement measures to deter theft and increase recovery. As the theft at the Corinth Archaeological Museum attests, theft costs the museum and its visitors a great deal—not only the monetary value of the objects, but also the time and effort of the museum staff to document the theft and publicize it, which takes the staff away from ongoing important projects. It denies the visitors the educational and aesthetic experience for which they come to a museum. Thefts cost the public, funding foundations, and governments. The ultimate cost is a public cost.

3. E. Burcaw 1997, p. 32.

Archaeologists and archaeological projects can also take action to reduce the number of thefts from archaeological excavations and laboratories. Archaeologists should include in their research budgets the cost of site security. Regardless of where in the world archaeological research is planned, the potential for theft during excavation exists. To ignore the potential for such theft from ongoing excavations and the field laboratories associated with them is irresponsible. Obviously, the risk varies from location to location, so the costs for security will also vary. But whether or not the risk is high or low, it does exist, and security measures should be considered a necessary expense for archaeological field investigation.

Lastly, museums must refuse to accept objects without provenance and provenience. Ignoring the history of ownership of an object (provenance) or the context of the find spot for archaeological objects (provenience) allows stolen objects to come into legitimate museums. It is true that if thieves cannot sell to legitimate galleries and museums, they will probably find a market for their stolen objects in private collections. This, however, should not influence the ethical decisions of museums. If museums refuse all objects without solid provenance or provenience, the market for art theft will shrink. In addition, the context of objects and their provenance is critical to interpretation and scholarship. Bookidis presents three excellent examples of the importance of context in her discussion: the Dionysus terracotta mask, the marble sphinx, and the Corinthian vases. In addition, without contextual information for an object, how can the museum or collector know for sure that an object is not a fabrication, a fake? The Cycladic mortuary sculptures are an excellent example of the problem of distinguishing authentic objects from recently fabricated ones.[4] If the provenance and provenience are not known, then interest and research about the object are misplaced, an effort wasted.

4. R. Elia 1996.

Related to this issue of museums, galleries, and art collectors acquiring objects of unknown or questionable provenance or provenience are the laws relating to art theft and the ethics of art dealers and museum curators. Bookidis points out that there is great variation in the laws defining art theft from country to country. In addition, the laws often contain ambiguous wording, which makes investigation and successful prosecutions more difficult. This is not easily or quickly solved, and museums or archaeological researchers certainly cannot solve it individually. Instead, professional organizations must accept the challenge to educate governments and to encourage them to write laws according to some international standard. This means that professional organizations for museums, art dealers, and archaeologists must agree on an international standard. In addition, proactive response by museums, auction houses, galleries, and professional organizations must be undertaken against those art dealers and museum curators whose questionable ethics make the sale of stolen art and artifacts easier. Such concerted actions of censure can be effective. Additionally, individual museums can avoid working with ethically questionable art dealers and auction houses, and make it clear that the reason for their reluctance to do business with them is their reputation for low ethical standards.

Conclusion

Of course we all recognize that all art theft cannot be stopped, but ethical behavior on the part of museum personnel, archaeologists, gallery owners, and auction houses can reduce the market and increase the chance for finding stolen objects. You cannot be responsible for other people's bad behavior, but you can work toward improving the security and the recovery of stolen art objects and artifacts. Ultimately, the cooperation between museums and archaeologists can make a difference. Together, museum directors, curators, trustees, and archaeologists have many areas of agreement

regarding art theft and the risks associated with the lack of provenance or provenience of museum objects. These areas of agreement should be the starting point for actions by all concerned with art theft and its prevention.

Bibliography

Burcaw, E. 1997. *Introduction to Museum Work.* 3rd edition. New York.

Elia, R. 1996. "A Seductive and Troubling Work." In *Archaeological Ethics,* ed. K. Vitelli, pp. 54–62. New York.

MacKenzie, S. 2005. "Criminal and Victim in Art Theft: Motive, Opportunity and Repeat Victimization." Paper presented at the AXA Art Conference, "Rogues Gallery: An Investigation Into Art Theft," November 1, 2005. At http://www.axa-art.com. Accessed January 2007.

Messenger, P., ed. 1999. *The Ethics of Collecting Cultural Property: Whose Property? Whose Culture?* 2nd edition. Albuquerque.

Phelan, M. 2006. "Legal and Ethical Considerations in Museum Acquisitions." In *Museum Philosophy for the Twenty-First Century,* ed. H. H. Genoways, pp. 27–46. Lanham, MD.

Stuart, G. 1999. "Conclusions: Working Together to Preserve Our Past." In *The Ethics of Collecting Cultural Property,* ed. P. M. Messenger, pp. 243–53. Albuquerque.

Vitelli, K., and C. Colwell-Chanthaphonh, eds. 2006. *Archaeological Ethics.* 2nd edition. New York.

Zimmerman, L., K. Vitelli, and J. Hollowell-Zimmer. 2003. *Ethical Issues in Archaeology.* New York.

Talking to the Troops about the Archaeology of Iraq and Afghanistan

C. Brian Rose

ARCHAEOLOGISTS AND MUSEUM CURATORS DEAL
with the antiquities market in one way or another every day of their
lives, especially the ethics of acquisitions, questions of provenance,
and the shifting character of international law.[1] The focus is gen-
erally on antiquities whose site of plunder cannot be identified,
either because such objects were continually traded in antiquity,
or because their style does not point toward a particular country of
origin.

Many in the museum community would favor the purchase of
an undocumented artifact on the art market to prevent it from dis-
appearing from the public eye forever; just as many archaeologists
would argue that the purchase of such artifacts fuels the market and

1. For assistance during the preparation of this article, I thank Mat-
thew Bogdanos, John Russell, Jack Davis, McGuire Gibson, Laurie Rush,
Patty Gerstenblith, Steve Dyson, Scott Silliman, Martha Joukowsky, Jane
Waldbaum, and Mark Rose. I am also grateful to Robin Rhodes and Charles
Loving for having invited me to participate in the conference.

spurs the plundering of even more sites. The two groups will probably not agree on a common course of action at any point in the immediate future, but both deplore the destruction of archaeological sites and the consequent loss of context. We may therefore be able to reach consensus in programs aimed at preventing the initial plundering of artifacts and their removal from the country of origin.

The Archaeological Institute of America (AIA) has recently launched a Troops Lecture program, focused on Iraq and Afghanistan, with precisely that goal.[2] The program's development was hardly straightforward, nor has its reach been as extensive as I initially hoped; but it represents the beginning of an outreach strategy that will ideally broaden in the future. In this article I present the story of the program and my involvement with it over the course of the last four years, in which I highlight the problems and rewards that arose in the course of the planning.

The idea for the program arrived in the wake of the Coalition intervention in Iraq, and is very much a by-product of the events associated with that intervention. When the Iraq Museum was looted, I was in my second year as First Vice President of the AIA. I recognized that the AIA needed to play as prominent a role as possible in the events that followed the looting, although determining which programs would be most potentially productive was not easy since none of our members had been working in Iraq or Afghanistan in the years immediately prior to the wars.

Bringing archaeologists from those countries to a special colloquium at the next annual meeting of the AIA (San Francisco, January 2004) seemed to be the best course of action, and funds quickly made available by the Packard Humanities Institute made it possible for us to do so.[3] Donny George, the director of the Iraq Museum, agreed to come, as did Abdul Wassey Feroozi, the director

2. Described in brief in J. Waldbaum 2005.

3. Following the destruction of the research libraries throughout Iraq in 2003, I attempted to develop a second program wherein graduate students in archaeology at Iraq universities would have the opportunity to

general of the National Institute of Archaeology in Afghanistan, although the sudden death of the director of the Iraq State Board of Antiquities and Heritage shortly before the annual meeting prevented Dr. George's participation.

In the course of the conference, Dr. Feroozi described the campaign of iconoclasm promoted by the Taliban, the rampant looting of museums and archaeological sites throughout his country, and the sale of so many undocumented Afghan and Iraqi antiquities on eBay.[4] In particular, he lamented the fact that the soldiers deployed in Afghanistan had little or no sense of the cultural heritage of the region.[5] Those comments put the conflict in Iraq and Afghanistan in a new perspective, and I suggested that the situation could be ameliorated if archaeologists were to go to U.S. military bases and provide briefings on the ancient history of the Middle East to the U.S. soldiers who were scheduled to be deployed there. Since the soldiers had become the primary security agents at both archaeological sites and museums, such briefings seemed essential in order to promote a greater comprehension of and respect for the cultural heritage of the areas in conflict. I hoped that this, in turn, would play a role in decreasing the number of antiquities smuggled out of the country and on to the art market.[6]

study for a semester or year at American universities. The potential funding sources I approached asked for an idea of how many universities and students this would involve, and wondered how we would be able to judge their fluency in English prior to their matriculation at American universities. Such information was impossible to retrieve in the early years of the war, and the program was never launched.

4. A. W. Feroozi 2004, with illustrations. Further information can be found on the website of the Association for the Protection of Afghan Archaeology: http://www.apaa.info/.

5. The conversation occurred at a lunch on January 4, 2004, and involved Dr. Feroozi, Robert Ousterhout, then of the University of Illinois, and myself.

6. For an overview of the looting at archaeological sites in Iraq, see F. Schipper 2005 and K. Romey 2002.

Dr. Feroozi agreed that such a program had enormous potential and encouraged me to launch it immediately. This was easier said than done, and I initially had no idea as to how to secure the military's approval. Archaeologists had periodically interfaced with the U.S. Armed Forces, especially during World War II, when they helped to pinpoint and safeguard archaeological sites, identify and repatriate looted works of art, and assist with cryptography.[7] But there had been very little interaction between the AIA and the military since that time, so no existing cooperative framework could be tapped.[8]

7. L. H. Nicholas 1994. For cryptography, see the entry on Elizabeth Thomas in the on-line version of G. Cohen and M. Joukowsky 2004. The most celebrated example is Gertrude Bell, Oriental Secretary in Iraq after 1917, who was influential in drawing the borders of the modern state of Iraq: G. Howell 2007; G. Cohen and M. Joukowsky 2004, pp. 142–97. For archaeologists working with the military in World War II, see M. Rose 1998.

8. During the First Gulf War, Scott Silliman, senior attorney for the U.S. Air Force's Tactical Air Command, worked with several archaeologists, including Robert McC. Adams and McGuire Gibson, to ensure that ancient sites in Iraq were not harmed during battle. A list of approximately eighty sites was reportedly compiled by the Department of Defense, and Martha Joukowsky, president of AIA at the time of the First Gulf War, was informed by the DoD that proper measures had been instituted to ensure the safety and preservation of archaeological remains and artifact collections in Iraq. In January of 2003, the AIA contacted the Departments of State and Defense regarding the danger of looting at archaeological sites in Iraq. In the same month McGuire Gibson met with officials from the Department of Defense and provided the DoD with a list of nearly 5,000 cultural and archaeological sites that were at risk. For an analysis of attitudes toward archaeology in Iraq during the First Gulf War, see S. Pollack and C. Lutz 1994. All major military installations in the United States have resident archaeologists on staff, most of who serve as their installation's Cultural Resources Manager. But these officials are generally experts in American archaeology, whereas AIA members tend to focus on the Mediterranean and the Near East. Increased contact and networking between these two groups could make a substantial contribution toward meeting military education goals.

No progress would have been possible without the active intervention of Marine Colonel Matthew Bogdanos, who had led the team in charge of recovering the antiquities stolen from the Iraq Museum.[9] We had been graduate students together in Mediterranean history and archaeology at Columbia in the early 1980s, and although we didn't know each other then, he was the only member of the Armed Forces I could identify whose life had spanned both of the worlds that would be embraced by the program I hoped to develop. He responded immediately and encouragingly to an email in which I explained the project in outline and asked for clarification of the proper channels through which the request for approval should be routed.

He advised me to send the proposal to General John Abizaid, head of the U.S. Central Command, and to emphasize the politically neutral character of the program. This kind of proposal was obviously very different from those that I was accustomed to writing, and after several attempts on my part, all of which were quickly and efficiently critiqued by Col. Bogdanos, I finally formulated and sent a proposal to General Abizaid that I quote here in part:

> As Vice-President of the Archaeological Institute of America (AIA), I write to propose a new educational program on the archaeology of Iraq and Afghanistan, to be delivered by AIA lecturers at the U.S. bases from which troops will be deployed to the Middle East.

> The troops find themselves in a culture that many of them have never studied, and they may be called upon to patrol

9. M. Bogdanos 2005a. Bogdanos has chronicled his work in recovering and securing the Iraq Museum in M. Bogdanos 2005b. John Russell spent several months in 2003 and 2004 working on the restoration of the museum, first as Deputy Senior Advisor for Culture (Sept 2003–March 2004), and then as Senior Advisor for Culture (April–June 2004). He was hired by the Department of Defense, which was entirely responsible for administering the reconstruction effort: see J. M. Russell 2004.

archaeological sites and museums associated with that culture. The briefings in the program we propose would deal with the civilizations of ancient Mesopotamia and Afghanistan, and provide general overviews of the sites/archaeological discoveries in these regions. Such a program would allow the troops to acquire a stronger sense of the ancient cultures with which they might be required to deal. The emphasis would be on history and culture; the lectures would be completely apolitical, and the goal would be educational outreach.

I understand from Colonel Matthew Bogdanos, Deputy Director of the Joint Interagency Coordination Group, that such lectures, if approved, would take place at different locations and different times during pre-deployment training. We are prepared to give such lectures whenever and wherever it is convenient for the U.S. Central Command. The AIA would like to launch a program that is pro-active but not political, and we hope that this series would generate positive publicity for everyone involved.

With the continued support and intervention of Col. Bogdanos, the proposal was finally approved in December of 2004. Now I had to determine how it could actually be executed. Approval from the U.S. Central Command (CENTCOM) did not guarantee that the doors of U.S. military bases would automatically be opened; the commanding officers at each of the bases where the lectures would be given had to be contacted, and the program needed to be approved by them as well. This situation can most easily be understood by employing an academic model: one can view CENTCOM as the university president, the Marine Corps and Army as individual colleges within that university, the base commanders as department heads, and the unit commanders as professors. Securing approval from a university president does not guarantee that the college deans and the department heads will sanction the task in question, and the same is true of the military.

We had already identified the Marine Corps base at Camp Lejeune as the site at which we hoped to inaugurate the program, since so many Marines on their way to Iraq received their predeployment briefings there. With the assistance of Col. Bogdanos, his associate Lt. Col. Bradley McAllister, and several officers at Camp Lejeune, I delivered the first lecture there in April of 2005. We subsequently added the Army base at Fort Bliss, where Robert Carr coordinated the briefings.

From the beginning of the program, I was amazed at the hospitality we were shown, especially in light of the large number of predeployment briefings that the Marines received. One of the commanding officers at Camp Lejeune was concerned that the briefing room in which I was scheduled to speak was not in sufficiently good condition for the lecture, and he arranged to have it painted and carpeted overnight.[10] At the conclusion of my first lecture, I was given a book (*Pictorial History of Baghdad*) signed by all of the officers at the base, as well as several other tokens of appreciation. At this time and in subsequent lectures, I was continually impressed by the quality of the questions that followed the briefings, such as "Who was the father of the Assurnasirpal II?," "What structures had been built on the inner side of the Ishtar Gate at Babylon?," and "Were Egyptian hieroglyphics earlier than cuneiform writing in Sumeria?"

Once the program had been approved, I had to determine several things: what precisely I wanted to communicate; how I could make the points most interesting and accessible; and how I could incorporate it into a thirty- to forty-five-minute format. The version that I now use evolved over the course of two years as I assessed which approaches did and did not work. In the case of those soldiers deployed to Iraq, I eventually realized that in order to make them regard the ground and its antiquities with the same kind of

10. At Camp Lejeune I thank, in particular, Col. Joseph Lydon, Col. Paul Hopper, Lt. Col. Ted Mija, Lt. Col. Richard Allen, and Lt. Col. Verne Seaton.

reverence held by archaeologists, I had to provide a framework that enabled them to find that sanctity within their own experience.

This was not as difficult as one might think, in that most of the soldiers had acquired some familiarity with this part of the world through the Bible. It quickly became clear that linking particular sites in Iraq to different accounts in Genesis was the easiest avenue of approach. I therefore included such topics as archaeological evidence for the Flood account, Abraham's birth at Ur, and Daniel/the Tower of Babel in Babylon, among others. I also emphasized our shared cultural heritage, i.e., the origins in Mesopotamia of political and social institutions that continue to form an integral part of our lives, such as the earliest evidence for written law codes, mathematics, astronomy, calendars, libraries, and schools.

In terms of chronology, I ultimately decided to begin with the new excavations at Göbekli Tepe in southeastern Turkey (ca. 9,000 BCE), since the site has been linked to the account in Genesis of the Garden of Eden, about which I was continually questioned by the soldiers.[11] I then move to the sixth millennium BCE, reviewing the suggested theories that the Flood accounts in the Near East derive from geological changes that transformed the Black Sea from fresh to salt water.[12] This leads to an overview of Mesopotamian geography, geographic and cultural differences between northern and southern Iraq, and the role of the ziggurat in Sumerian society. I focus on the ziggurat of Ur, in particular, since this is the area in which many are stationed.

A subsequent examination of the royal tombs of Ur allows me to demonstrate the importance of objects in context, and to communicate the techniques that archaeologists regularly use in the course of historical reconstruction, including paleobotany, faunal analysis, and physical anthropology. My goal has been to summarize for the soldiers the extent of the historical loss if a site is plundered, and to highlight the fundamental interrelationship of the

11. K. Schmidt 2001 and 2006.
12. R.D. Ballard, D. F. Coleman, and G. D. Rosenberg 2000.

artifacts in archaeological analysis. I found that most of them already have at least a slight familiarity with the Kingdom of Babylon, both Old and New, since Babylon is the site of one of the principal U.S. military bases in southern Iraq, and Hammurabi's portrait now adorns the 25,000 dinar note in the new Iraq currency.

I usually treat Afghanistan in less detail than Iraq, since far more soldiers are deployed to the latter area. I tend to begin the Afghanistan discussion with the campaigns of Alexander, emphasizing the cities that bore his name as founder, such as Kandahar, and stressing the Hellenic influences on the language, art, and religion of the region. I actually move back and forth between Iraq and Afghanistan during this section, since some of Alexander's campaigns in these areas resonate with the soldiers' own experience and knowledge: the crude petroleum set on fire by the inhabitants near ancient Kirkuk is not so different from the actions of the Iraqi soldiers during the First Gulf War, while some of the difficulties experienced by Alexander in the Hindu Kush mountains of northern Afghanistan have been witnessed again in the maneuvers of the Coalition Forces.[13] I end the section on Afghanistan with the introduction of Buddhism, the carving of the colossal Buddhas in the cliffs of Bamiyan, and the Taliban's iconoclasm. In the conclusion, I stress that the soldiers' vigilance in safeguarding sites and museums determines whether the historical foundations that I have just presented will survive in the future.

When I began the program, my hope was that we would eventually expand it to every base from which soldiers were being deployed to the Middle East, which meant that it would not be practical for me to handle all of the briefings myself. Since few of us are experts in the archaeology of Iraq and Afghanistan, I prepared a master script with accompanying PowerPoint that could be circulated to others giving the presentation, in order to make the task less daunting. The process of lecturing on a military base is obviously

13. Plutarch *Alexander* 35.1–7.

very different from an AIA lecture tour: training schedules can change suddenly in the Armed Forces, and one has to react rapidly and diplomatically to alterations in the timing of the briefings. Over time I have found that archaeologists with prior military experience had an easier time adapting to such shifting requirements, and a number of the lecturers have been Vietnam veterans.[14]

The question always arises as to whether the soldiers are actually absorbing the information I present, and whether one can gauge the effect it has on them. In every briefing I have given, the enlisted soldiers and officers have been riveted to the material being presented, and the other archaeologists who have given the briefings have received emails and letters from soldiers stationed in Iraq, who ask additional questions about the presentation, or describe their attempts to safeguard mud-brick structures inadvertently uncovered during construction, or chronicle their attempts to hinder looting.

When I mention site plundering in AIA lectures, I often need to remind the audience that looters are not debonair rogues analogous to Cary Grant in *To Catch a Thief*. But this kind of analysis is not necessary for the soldiers, who routinely discover caches of stolen antiquities mixed with drugs and weapons. The sale of drugs and looted antiquities is one of the funding sources for terrorism, as Matthew Bogdanos has pointed out, and antiquities smuggling is only one component of an international crime network that enriches itself in any way that might be potentially productive.[15]

My initial goal was to see the Troops Lectures program adopted by all other countries that are deploying troops to the Middle East, so that the cultural awareness training would be as broad-based as possible. So far it has been adopted by Bulgaria, which sends troops to both Iraq and Afghanistan, and by Germany, whose troops are deployed in northern Afghanistan. The AIA is attempting to pro-

14. I thank the other archaeologists who have delivered the Troops Lectures at either Camp Lejeune or Fort Bliss: Jodi Magness, Elise Friedland, Wayne Lee, Al Leonard, and Paul Zimansky.

15. M. Bogdanos 2005c.

mote its integration into the training programs of the other countries as well, but progress has not been as rapid as we had hoped. The AIA's Troop Lecture Program is only one of several that have been launched since the beginning of armed conflict in Iraq and Afghanistan. A complementary initiative is being sponsored by the American Institute for Conservation and the U.S. Committee of the Blue Shield, the cultural equivalent of the Red Cross.[16] This program, conducted by Cori Wegener, a retired major in the Army Reserves, John Russell, AIA Vice President for Professional Responsibilities, and conservator Barbara Roberts, involves briefing troops of the 352nd Civil Affairs Command on the basics of Civil Affairs Arts, Monuments, and Archives responsibilities so that they can provide cultural heritage expertise to commanders in combat zones. Similar lectures have also been delivered by Geoff Emberling, the director of the Museum of the Oriental Institute at the University of Chicago, as part of a graduate-level program based at the Naval Postgraduate School in Monterey, California.[17]

In 2006 Dr. Laurie Rush, Cultural Resources Manager at Fort Drum, created a new Cultural Heritage Training Project for deploying personnel that is funded by the Department of Defense Legacy Program. The project's purpose is to demonstrate that careful treatment of heritage sites overseas is integral to the success of the military mission. Military personnel of all levels are provided with "user friendly" training materials, which include decks of "archaeology awareness" playing cards.

Each card contains photos of cultural heritage sites in Iraq and Afghanistan accompanied by didactic captions such as "Ancient sites matter to the local community. Showing respect wins hearts and minds"; "Purchasing ancient 'souvenirs' helps fund insurgents. Do not buy them!"; and "A looted archaeological site means that details of our common past are lost forever."[18]

16. http://www.americanblueshield.org.

17. Prof. Anne Killebrew has delivered similar lectures to ROTC at Penn State University.

18. V. Schlesinger 2007.

All of this leads back to the topic with which I began this article—seeking strategies to prevent the plunder of sites and the sale of stolen, undocumented antiquities. The program outlined above is only a small part of the solution to the current spoliation of history. As a museum curator and an archaeologist, I remain convinced that both groups can find common ground, and that we should search for that ground more energetically than has been the case in the past. Our passion for the art and material culture of antiquity stems from an equally passionate interest in the societies that produced them, and this is surely enough of a foundation for collegial interaction.

As tragic as it is to contemplate, wars will continue to be fought and the material culture of the ancient world will continue to be placed in jeopardy. A unified response by those of us who have chosen to devote our lives to the study of antiquity is required if any real progress is to be made in the future. This means dismantling the barriers to communication that have continually been constructed while simultaneously reaching out more forcefully to the international community. The Notre Dame conference, with its mix of archaeologists, cultural property lawyers, and museum directors and curators, has served as a necessary first step in that direction.

Bibliography

Ballard, R. D., D. F. Coleman, and G. D. Rosenberg. 2000. "Further Evidence for Abrupt Holocene Drowning of the Black Sea Shelf." *Marine Geology* 170, pp. 253–61.

Bogdanos, M. 2005a. "The Casualties of War: The Truth about the Iraq Museum." *AJA* 109, pp. 477–526.

———. 2005b. "The Terrorist in the Art Gallery." *New York Times*, December 10.

———. 2005c. *Thieves of Baghdad: One Marine's Passion for Ancient Civilizations and the Journey to Recover the World's Greatest Stolen Treasures.* New York.

Cohen, G., and M. Joukowsky, eds. 2004. *Breaking Ground: Pioneering Women Archaeologists.* Ann Arbor. Available at http://www.brown.

edu/Research/Breaking_Ground/results.php?d=1&first=Elizabeth&
last=Thomas.

Feroozi, A. W. 2004. AIA conference paper. Available at http://www.
archaeological.org/webinfo.php?page=10242.

Howell, G. 2007. *Gertrude Bell: Queen of the Desert, Shaper of Nations.*
London.

Nicholas, L. H. 1994. *The Rape of Europa: The Fate of Europe's Treasures in
the Third Reich and the Second World War.* New York.

Pollack, S., and C. Lutz. 1994. "Archaeology Deployed for the Gulf War."
Critique of Anthropology, pp. 263–84.

Romey, K. 2002. "The Race to Save Afghan Culture." *Archaeology* 55.3,
pp. 18–25.

Rose, M. 1998. http://www.archaeology.org/online/features/50years/index.
html.

Russell, J. M. 2004. "Art Loss in Iraq: An Overview of the Losses." *IFAR* 7.2,
pp. 54–63.

Schipper, F. 2005. "The Protection and Preservation of Iraq's Archaeologi-
cal Heritage, Spring 1991–2003." *AJA* 109.2, pp. 251–72.

Schlesinger, V. 2007. "From the Trenches: Desert Solitaire." *Archaeology*
60.4, p. 9. Available at http://www.archaeology.org/0707/trenches/
solitaire.html.

Schmidt, K. 2001. "Göbekli Tepe, Southeastern Turkey: A Preliminary Re-
port on the 1995–1999 Excavations." *Paléorient* 26/1, pp. 45–54.

———. 2006. *Sie bauten die ersten Tempel: Das rätselhafte Heiligtum der
Steinzeitjäger.* Munich.

Waldbaum, J. 2005. "From the President: Tell It to the Marines." *Archae-
ology* 58.6, p. 6.

Response to C. Brian Rose

Marcia Rickard

Aftᴇʀ sᴘᴇᴀᴋɪɴɢ ᴛᴏ ᴘʀᴏғᴇssᴏʀ ʀᴏsᴇ ᴀʙᴏᴜᴛ ʜɪs horror at learning of the looting of the Baghdad Museum and the subsequent appearance of items on eBay, I thought about what is so different at this moment in time from previous periods of looting, especially during war. It is the technological mechanisms available to anyone with a cell phone or computer which allow access to a global market from anywhere in the world. Roger Atwood, in *Stealing History* (New York, 2004), tells of accompanying Peruvian looters on an excursion to remote tombs on their northern coast. They already know what is "hot" on the global market and will jettison and often destroy what is not. After a night's successful digging, they contact several intermediaries by cell phone early the next morning to alert them to the objects and negotiate price. The successful intermediary, in turn, has the objects on a plane out of the country in one or two days to a dealer halfway around the world. With long-haul plane flights operating out of countries rich in archaeological remains, fewer stops where contraband can be detected are necessary. Thus an object in the ground in Peru on Monday may be in a dealer's showroom in New York on Friday.

But what about the breathtaking accessibility to Internet markets? I made my own unscientific foray onto eBay in search of Iraqi artifacts. On February 22, 2007, I searched "Antiquities" in various

categories. Under "Egyptian Antiquities" I found 1470 items; under "Greek," 626 items; "Roman," 1498; and under "Other," 1082 objects. I looked in this latter category for "Iraqi artifacts" but found not a single item listed as from Iraq. Clearly eBay is flagging those and "Afghanistan." However, there were numerous other designations: "Near Eastern," "Middle Eastern," "Hellenistic," "Syrian," "Iranian," "Phoenician," "Turkish," "Luristan," "Assyrian," "Achaemenid," "Umayyad," "Tel Halaf," "Sassanian," and my personal favorite, "Ancient Holyland Iron Age." In other words, objects from ancient cultures in or around Iraq are still available, most at ridiculously low prices.

If the Internet is making the marketing of looted objects easier, then how is the Internet helping to monitor or, better still, prevent stolen and looted goods from reaching the market? Shouldn't the Internet's ability to make images quickly available help us in this? Again, I searched eBay, for guidelines established for listing objects. It's not easy finding them, however. From their on-line Security Center, one goes to "Prohibited and Restricted Items" to "Artifacts" to "International Trading" to "Additional Information" to "Importation of Cultural Items." There one finds links to sites of interest.

The State Department's Cultural Property Advisory Committee is very helpful and offers several important links from its site, among them the ICOM (International Council on Museums) Red List and Interpol. Both are working in cooperation with UNESCO and have special website emergency tools for customs officials, police officers, art dealers, and collectors to help them recognize objects that could originate from Iraq. For example, the ICOM Red List includes categories of objects arranged in order of how frequently they appear on the art market:

1. Tablets of clay or stone with cuneiform writing
2. Cones and any other objects with cuneiform writing
3. Cylinder seals of stone, shell, frit, etc.
4. Stamp seals of stone, shell, etc., and their impressions
5. Ivory, bone plaques and sculptures

6. Sculpture
7. Vessels
8. Jewelry
9. Manuscripts, calligraphy, books
10. Architectural and furniture fragments
11. Coins

For each category, one can click on digital photos with descriptions of how to recognize these illicit antiquities. Since much of what is entering the market illegally had never been photographed before being advertised on the Internet, this seems the best way for wary buyers or enforcement agencies to operate. Indeed, I found examples from each category in my eBay search. Interpol has a similar sets of images.

As a coda, I'd like to add a cautionary tale relayed to me by an archaeologist friend just last week. She bought a medieval Persian lamp on eBay which claimed to have a provenance from an English collection. When it arrived, it was still covered in dirt as if "it had been dug up recently." As she said ruefully, "Even specialists with the best of intentions can be fooled."

Helpful Websites with Image Databases

Art Loss Register
 www.artlossregister.com
FBI National Stolen Art File (NASF)
 www.fbi.gov/hq/cid/arttheft/nationalstolen
ICOM Red List
 www.icom.museum/redlist
Interpol
 www.interpol.int/Public/WorkOfArt
U.S. State Department Advisory Committee on Cultural Property, especially the link to "Efforts to Protect Cultural Property Worldwide"
 www. exchanges.state.gov/culprop

Conclusion

Robin F. Rhodes

PRESENTED IN THIS VOLUME ARE THE PAPERS AND responses delivered at the symposium "The Acquisition and Exhibition of Classical Antiquities: Professional, Legal, and Ethical Perspectives," held on February 24, 2007, in the Snite Museum of Art at the University of Notre Dame. Not transcribed here is the lively open discussion that followed both the morning and the afternoon sessions. A DVD archive of the entire proceedings exists in the collection of the Hesburgh Library at Notre Dame and in the Snite Museum.

The range of experience and perspective of the symposium participants was broad, including at one end of the spectrum the American director of one of the world's great encyclopedic museums, at the other an Italian field archaeologist charged, among other things, with the responsibility of protecting provincial archaeological sites in Sicily from looting. The great divide between these two perspectives still seems to surround the issues of context and accessibility. Encyclopedic museum directors argue that the multicultural context of objects in an encyclopedic museum and their ability through their wide accessibility to provide multicultural education to a huge international audience should be valued above the more narrowly defined context of archaeological provenience. The archaeologist, on the other hand, argues that

without an understanding of the original context of the object (which the illicit trade in antiquities obscures or destroys completely), the value of the object both as a cultural artifact and as a work of art is profoundly and permanently compromised. Further, the continued support of the illicit antiquities market through the purchase of unprovenanced or insufficiently provenanced objects ensures the continued destruction of archaeological sites and exposes as moral posturing the claim of encyclopedic museums to be institutions committed to preservation and education.

Legal perspectives can also present seemingly paradoxical dichotomies. On the one hand, it was argued that the historically irresponsible acquisitions policies of some museums, which reflect a lack of respect for the laws of countries of origin, contribute directly to the trade in illicit antiquities and to the consequent destruction of knowledge and that, therefore, the tax-exempt status of these museums as institutions of education should by law be revoked. On the other hand, the question was raised of whether, in the context of international law, a modern nation that cannot or will not protect its cultural heritage should be allowed sole responsibility for the stewardship of objects originally created in a geographical area that now lies within the boundaries of that nation. Field archaeologists and museum professionals alike acknowledged this dichotomy as reflective of the paradoxical structure of a modern world that is increasingly globalized and, at the same time, increasingly Balkanized through narrow, nationalistic, political agendas. And while the utilitarian analysis employed by some encyclopedic museums to justify the acquisition of antiquities of questionable provenance (the more people who see them, the greater the good) has seemed self-serving and disingenuous to some field archaeologists, this symposium revealed a real convergence of goals between the director of the Chicago Art Institute and the former director of the American School excavations at Ancient Corinth (itself the victim of an antiquities-market-inspired heist). Both called for the opening up of access to the world's antiquities, the former through the multiplication of encyclopedic museums throughout

the world, the latter through the obligatory worldwide sharing of antiquities, effected by means of an immediate and radical increase in extended loans of antiquities and traveling exhibitions.

Everyone agrees that looting is bad. And it is undeniable that the looting of ancient sites is a direct result of the international market for illicit antiquities. The Corinth theft was presented as a paradigm of that causal relationship and of the wide circle of its tragic consequences, and of the need to protect archaeological sites and museums from depredation. It was also presented as a paradigm of the practicalities of response to such crime. A remarkably direct educational approach to preventing the destruction of cultural heritage was presented in a description of a new orientation program on the responsibilities of U.S. troops toward cultural property, designed and implemented by the new president of the Archaeological Institute of America and required of every American soldier before deployment in Iraq or Afghanistan. And the internet was presented as an immensely complicating new factor in the regulation of the antiquities market.

Inevitably, the question raised was, What do museums and other institutions of education do either to encourage or discourage the trade in illegally procured antiquities, and what *should* they do? A predictably broad spectrum of opinion and suggestions was expressed among the symposiasts, including the increasingly important voice of university museum directors, whose constituency and mission inevitably place them in a position of compromise between the encyclopedic museum and the field archaeologist. The university museum builds and maintains collections of art, but it does so in direct collaboration with the goals and research of the university faculty. For the university museum, policies of acquisition are more than simply practical or legal guidelines. They are also expressions of principle, of the mutual respect and productive interaction between museum and research faculty, of the broader educational mission of the university as a whole, and of the values inherent in centers of liberal research: humanitarian, international, multicultural respect and cooperation. As a result, many university

museums are adopting in their acquisitions policy the guidelines of the UNESCO convention, officially approved by the Archaeological Institute of America, a significantly stricter policy of acquisitions than that officially endorsed by the Association of Art Museum Directors (AAMD).

The development of a comprehensive policy for the repatriation of antiquities is perhaps impossible, and this is sometimes invoked as a distraction, as proof that any resolution of the issues of cultural property is hopeless. But everyone agrees that the looting of cultural property should be stopped, and there is no question that the looting of cultural property is encouraged by the market in unprovenanced or poorly provenanced antiquities. Most agree that the UNESCO convention is a useful guide in the establishment of acquisition policies, though the specifics are argued even between archaeologists. In order for an artifact to be considered for sale or acquisition, should its unbroken paper trail go back at least as far as 1970 (as suggested by the UNESCO convention) or only ten years (as suggested by the AAMD)? In other words, there seems to be general consensus on the principle involved, but the strategies of implementation are still debated. If, as seems to be the case, a common denominator (if not always the primary concern) for all the participants in this symposium is a desire to end the destruction of ancient sites and the looting of their artifacts, then, as one respondent suggested, regardless of whether the date adopted by purchasing institutions is that of UNESCO or of the AAMD or "even tomorrow," with the adoption of any date at all "*looting would immediately become a less lucrative proposition, because these conduits and buyers would be eliminated from the market.*"

The consensus on the need to protect ancient sites was accompanied by unanimous agreement in a number of important areas:

1. that museums and universities have significant roles to play in these matters and that a cooperative relationship between the two is necessary and should be promoted through similar symposia and cooperative projects;

2. that the time is ripe to rethink, rearticulate, and reinstitute policies and practices (including exhibition strategies) that protect and promote cultural artifacts throughout the world;

3. that the public needs to be educated on these issues;

4. that the crux of the matter does not lie in an antipathy between art museums and archaeologists, but in the plundering of the world's cultural heritage;

5. that the university museum can play a vital role in the mediation of these issues and constituencies;

6. that a given constituency is not necessarily monolithic in its point of view;

7. that there is more basic agreement between constituencies than we had formerly thought, certainly enough for continued, profitable, cooperative discussion and planning.

It is the hope of all participants that this symposium and volume have helped establish a useful benchmark in the discussion of the issues surrounding the acquisition and exhibition of antiquities; that they will encourage future discussions; that those discussions will be many and varied; and that consensus will continue to be built, step by step, issue by issue.

Appendix

Convention on the Means of Prohibiting and
Preventing the Illicit Import, Export and
Transfer of Ownership of Cultural Property 1970
(Articles 1–13 of 26)

PARIS, 14 NOVEMBER 1970

The General Conference of the United Nations Educational, Scientific and Cultural Organization, meeting in Paris from 12 October to 14 November 1970, at its sixteenth session,

Recalling the importance of the provisions contained in the Declaration of the Principles of International Cultural Co-operation, adopted by the General Conference at its fourteenth session,

Considering that the interchange of cultural property among nations for scientific, cultural and educational purposes increases the knowledge of the civilization of Man, enriches the cultural life of all peoples and inspires mutual respect and appreciation among nations,

Considering that cultural property constitutes one of the basic elements of civilization and national culture, and that its true value can be appreciated only in relation to the fullest possible information regarding is origin, history and traditional setting,

Considering that it is incumbent upon every State to protect the cultural property existing within its territory against the dangers of theft, clandestine excavation, and illicit export,

Considering that, to avert these dangers, it is essential for every State to become increasingly alive to the moral obligations to respect its own cultural heritage and that of all nations,

Considering that, as cultural institutions, museums, libraries and archives should ensure that their collections are built up in accordance with universally recognized moral principles,

Considering that the illicit import, export and transfer of ownership of cultural property is an obstacle to that understanding between nations which it is part of UNESCO's mission to promote by recommending to interested States, international conventions to this end,

Considering that the protection of cultural heritage can be effective only if organized both nationally and internationally among States working in close co-operation,

* * * *

Adopts this Convention on the fourteenth day of November 1970.

Article 1

For the purposes of this Convention, the term 'cultural property' means property which, on religious or secular grounds, is specifically designated by each State as being of importance for archaeology, prehistory, history, literature, art or science and which belongs to the following categories:

(a) Rare collections and specimens of fauna, flora, minerals and anatomy, and objects of palaeontological interest;

(b) property relating to history, including the history of science and technology and military and social history, to the life of national leaders, thinkers, scientists and artists and to events of national importance;

(c) products of archaeological excavations (including regular and clandestine) or of archaeological discoveries;

(d) elements of artistic or historical monuments or archaeological sites which have been dismembered;

(e) antiquities more than one hundred years old, such as inscriptions, coins and engraved seals;

(f) objects of ethnological interest;

(g) property of artistic interest, such as:

(i) pictures, paintings and drawings produced entirely by hand on any support and in any material (excluding industrial designs and manufactured articles decorated by hand);

(ii) original works of statuary art and sculpture in any material;

(iii) original engravings, prints and lithographs;

(iv) original artistic assemblages and montages in any material;

(h) rare manuscripts and incunabula, old books, documents and publications of special interest (historical, artistic, scientific, literary, etc.) singly or in collections;

(i) postage, revenue and similar stamps, singly or in collections;

(j) archives, including sound, photographic and cinematographic archives;

(k) articles of furniture more than one hundred years old and old musical instruments.

Article 2

1. The States Parties to this Convention recognize that the illicit import, export and transfer of ownership of cultural property is one of the main causes of the impoverishment of the cultural heritage of the countries of origin of such property and that international co-operation constitutes one of the most efficient means of protecting each country's cultural property against all the dangers resulting there from.

2. To this end, the States Parties undertake to oppose such practices with the means at their disposal, and particularly by removing their causes, putting a stop to current practices, and by helping to make the necessary reparations.

Article 3

The import, export or transfer of ownership of cultural property effected contrary to the provisions adopted under this Convention by the States Parties thereto, shall be illicit.

Article 4

The States Parties to this Convention recognize that for the purpose of the Convention property which belongs to the following categories forms part of the cultural heritage of each State:

(a) Cultural property created by the individual or collective genius of nationals of the State concerned, and cultural property of importance to the State concerned created within the territory of that State by foreign nationals or stateless persons resident within such territory;

(b) cultural property found within the national territory;

(c) cultural property acquired by archaeological, ethnological or natural science missions, with the consent of the competent authorities of the country of origin of such property;

(d) cultural property which has been the subject of a freely agreed exchange;

(e) cultural property received as a gift or purchased legally with the consent of the competent authorities of the country of origin of such property.

Article 5

To ensure the protection of their cultural property against illicit import, export and transfer of ownership, the States Parties to this Convention undertake, as appropriate for each country, to set up within their territories one or more national services, where such services do not already exist, for the protection of the cultural heritage, with a qualified staff sufficient in number for the effective carrying out of the following functions:

(a) contributing to the formation of draft laws and regulations designed to secure the protection of the cultural heritage and particularly prevention of the illicit import, export and transfer of ownership of important cultural property;

(b) establishing and keeping up to date, on the basis of a national inventory of protected property, a list of important public and private cultural property whose export would constitute an appreciable impoverishment of the national cultural heritage;

(c) promoting the development or the establishment of scientific and technical institutions (museums, libraries, archives, laboratories, workshops . . .) required to ensure the preservation and presentation of cultural property;

(d) organizing the supervision of archaeological excavations, ensuring the preservation 'in situation' of certain cultural property, and protecting certain areas reserved for future archaeological research;

(e) establishing, for the benefit of those concerned (curators, collectors, antique dealers, etc.) rules in conformity with the ethical prin-

ciples set forth in this Convention; and taking steps to ensure the observance of those rules;

(f) taking educational measures to stimulate and develop respect for the cultural heritage of all States, and spreading knowledge of the provisions of this Convention;

(g) seeing that appropriate publicity is given to the disappearance of any items of cultural property.

Article 6

The States Parties to this Convention undertake:

(a) To introduce an appropriate certificate in which the exporting State would specify that the export of the cultural property in question is authorized. The certificate should accompany all items of cultural property exported in accordance with the regulations;

(b) to prohibit the exportation of cultural property from their territory unless accompanied by the above-mentioned export certificate;

(c) to publicize this prohibition by appropriate means, particularly among persons likely to export or import cultural property.

Article 7

The States Parties to this Convention undertake:

(a) To take the necessary measures, consistent with national legislation, to prevent museums and similar institutions within their territories from acquiring cultural property originating in another State Party which has been illegally exported after entry into force of this Convention, in the States concerned. Whenever possible, to inform a State of origin Party to this Convention of an offer of such cultural property illegally removed from that State after the entry into force of this Convention in both States;

(b) (i) to prohibit the import of cultural property stolen from a museum or a religious or secular public monument or similar institution in another State Party to this Convention after the entry into force of this Convention for the States concerned, provided that such property is documented as appertaining to the inventory of that institution;

(ii) at the request of the State Party of origin, to take appropriate steps to recover and return any such cultural property imported after the entry into force of this Convention in both States concerned, provided, however, that the requesting State shall pay just compensation to an innocent purchaser or to a person who has valid title to that property. Requests for recovery and return shall be made through diplomatic offices. The requesting Party shall furnish, at its expense, the documentation and other evidence necessary to establish its claim for recovery and return. The Parties shall impose no customs duties or other charges upon cultural property returned pursuant to this Article. All expenses incident to the return and delivery of the cultural property shall be borne by the requesting Party.

Article 8

The States Parties to this Convention undertake to impose penalties or administrative sanctions on any person responsible for infringing the prohibitions referred to under Articles 6(b) and 7(b) above.

Article 9

Any State Party to this Convention whose cultural patrimony is in jeopardy from pillage of archaeological or ethnological materials may call upon other States Parties who are affected. The States Parties to this Convention undertake, in these circumstances, to participate in a concerted international effort to determine and to carry out the necessary concrete measures, including the control of

exports and imports and international commerce in the specific materials concerned. Pending agreement each State concerned shall take provisional measures to the extent feasible to prevent irremediable injury to the cultural heritage of the requesting State.

Article 10

The States Parties to this Convention undertake:

(a) To restrict by education, information and vigilance, movement of cultural property illegally removed from any State Party to this Convention and, as appropriate for each country, oblige antique dealers, subject to penal or administrative sanctions, to maintain a register recording the origin of each item of cultural property, names and addresses of the supplier, description and price of each item sold and to inform the purchaser of the cultural property of the export prohibition to which such property may be subject;

(b) to endeavour by educational means to create and develop in the public mind a realization of the value of cultural property and the threat to the cultural heritage created by theft, clandestine excavations and illicit exports.

Article 11

The export and transfer of ownership of cultural property under compulsion arising directly or indirectly from the occupation of a country by a foreign power shall be regarded as illicit.

Article 12

The States Parties to this Convention shall respect the cultural heritage within the territories for the international relations of which they are responsible, and shall take all appropriate measures to prohibit and prevent the illicit import, export and transfer of ownership of cultural property in such territories.

Article 13

The States Parties to this Convention also undertake, consistent with the laws of each State:

(a) To prevent by all appropriate means transfers of ownership of cultural property likely to promote the illicit import or export of such property;

(b) to ensure that their competent services co-operate in facilitating the earliest possible restitution of illicitly exported cultural property to its rightful owner;

(c) to admit actions for recovery of lost or stolen items of cultural property brought by or on behalf of the rightful owners;

(d) to recognize the indefeasible right of each State Party to this Convention to classify and declare certain cultural property as inalienable which should therefore ipso facto not be exported, and to facilitate recovery of such property by the State concerned in cases where it has been exported.

* * * *

Full text available at: http://portal.unesco.org/en/ev.php-URL_ID=13039&URL_DO=DO_TOPIC&URL_SECTION=201.html

Participants

Malcolm Bell III is Professor of Greek Art and Archaeology at the University of Virginia and is co-director of the University of Virginian Excavations at Morgantina, Sicily. In addition to his many publications and papers on classical art and archaeology, he has lectured widely on the topic of ethics and archaeology, especially on the looting of classical sites and the repatriation of classical antiquities. He has helped bring this issue to the general public through his participation in various symposia and through his recent editorials in the *New York Times*, the *LA Times*, and the *Art Newspaper*. He was professor-in-charge of the School of Classical Studies at the American Academy in Rome and A. W. Mellon Professor at the Center for Advanced Study in the Visual Arts at the National Gallery of Art, and is a past recipient of a Guggenheim Fellowship, an NEH Fellowship, an American Academy in Rome Fellowship, and a Fulbright Fellowship.

Nancy Bookidis has worked at the Corinth Excavations of the American School of Classical Studies at Athens since 1968, as co-director of the Demeter Sanctuary Excavations, as fellow of the Corinth Excavations, as curator of the Excavations, and as assistant director of the Excavations. For more than thirty years she was responsible for the American Excavation collection housed in the Corinth Museum and, together with the director, Charles Williams II, established a data base for the cataloguing of finds and trained students of the American School in museum work. In 1990, when the museum was robbed, it was her responsibility to catalogue the theft, see to its publication, and to try to keep up interest in it over the years. Most recently, Nancy has co-authored the *Corinth Excavations* volume on the architectural remains of the Demeter Sanctuary and

has submitted her manuscript for the volume on the large-scale ter-
racotta sculpture there.

Douglas E. Bradley is Curator of the Arts of the Americas, Africa,
and Oceania at the Snite Museum of Art at the University of Notre
Dame. He has developed the Mesoamerican Pre-Columbian collec-
tions in the Snite Museum to an internationally renowned level since
he joined the museum in 1979. He specializes in Olmec art, Preclas-
sic period figurines, and the ritual ballgame. As curator, he is respon-
sible for new acquisitions, exhibitions, research, and publication of
the collection. He reinstalled the Mesoamerican gallery in 2003 and
the African gallery in 2006. Bradley is concurrent assistant professor
in the departments of Anthropology and Art, and teaches courses in
Mesoamerican art and African art each fall semester.

James Cuno is President and Director of the Art Institute of Chi-
cago. Previously he has been professor and director of the Courtauld
Institute of Art, University of London, and professor and director of
the Harvard University Art Museums. He has written often and lec-
tured widely on the question of art museums and the acquisition
of antiquities, and he recently edited an important collection of es-
says on that issue, *Whose Muse? Art Museums and the Public's Trust*
(Princeton University Press, 2003). In spring 2006 he moderated the
Association of Art Museum Directors symposium "Museums and the
Collecting of Antiquities—Past, Present and Future." He has served
as the president of the Association of Art Museum Directors (com-
prising North America's largest art museums) and is a fellow of the
American Academy of Arts and Sciences.

Dennis P. Doordan is Chair of the Department of Art, Art History,
and Design at the University of Notre Dame and holds a joint ap-
pointment in that department and in the School of Architecture. He
is an architectural and design historian, museum consultant, and co-
editor of *Design Issues*, a journal devoted to the history, theory, and
criticism of design. He has served as an exhibition consultant and
contributed catalog essays for architecture and design exhibitions or-
ganized by the Art Institute of Chicago, the Carnegie Museum of Art

in Pittsburgh, the Guggenheim Museum in New York City, the Los Angeles County Museum of Art, the Toledo Art Museum, and the Wolfsonian Foundation in Miami Beach. He has published books and articles on a wide variety of topics in twentieth-century architecture and design, including political themes in architecture, the impact of new materials, and the evolution of exhibition design techniques.

Patty Gerstenblith is Professor of Law at DePaul University College of Law and has become the most prominent spokesperson for the legal perspective on the acquisition and exhibition of antiquities. She is director of DePaul's program in art and cultural heritage law and co-chair of the American Bar Association's International Cultural Property Committee. She served as editor-in-chief of the *International Journal of Cultural Property* from 1995 to 2002 and as a public representative on the President's Cultural Property Advisory Committee from 2000 to 2003. Her book *Art, Cultural Heritage and the Law* was published in 2004. She received her J.D. from Northwestern University and a Ph.D. from Harvard University in fine art and anthropology. She served as a clerk to the Honorable Richard D. Cudahy of the Seventh Circuit Court of Appeals in 1983–84.

Charles R. Loving is Director of the Snite Museum of Art at the University of Notre Dame and Curator of its George Rickey Sculpture Archive. Before assuming this position in 2000, he was interim director and associate director of the Snite Museum. Prior to Notre Dame, he was assistant director of the Utah Museum of Fine Arts, University of Utah, where he received an MA in 1985 and an MFA in 1982. He attended art school at the University of Wisconsin, Milwaukee, BFA 1980. Loving is currently writing a book on American sculptor Richard Hunt and preparing an exhibition and catalog of George Rickey sculptures.

Michael Lykoudis is Dean of the School of Architecture at the University of Notre Dame. A national and international leader in linking architectural tradition and classicism to urbanism and environmental issues, he has devoted his career to the building, study, and

promotion of traditional architecture and urbanism. His activities feature the organization of several international conferences that have been collaborations between Notre Dame and other organizations, including the Classical Architecture League and the Institute of Classical Architecture and Classical America. Lykoudis is the co-editor of *Building Cities*, published in 1999 by Artmedia Press, and *The Other Modern* exhibition catalogue, published in 2000 by Dogma Press. A third book, *Modernity, Modernism and the Other Modern*, is forthcoming from W. W. Norton. He also served as a site architect for various excavations in Greece.

Joanne M. Mack is Curator of Native American Art at the Snite Museum and concurrent associate professor of Anthropology at Notre Dame. The focus of her research includes North American archaeology, Native American art, and museum studies, especially the presentation and perception of Native American objects in art, history, and natural history museums. Recognized as the expert on the ceramics from archaeological sites in the Southern Cascades, she is also the primary archaeological researcher for a twenty-five-mile stretch of the Upper Klamath River in Oregon and California. She has written several monographs concerned with the archaeological resources within that area and their significance. In addition, she has just finished a National Register Nomination for a group of archaeological sites located within the California portion of this research area.

Mary Ellen O'Connell is the Robert and Marion Short Chair in Law at the University of Notre Dame and is the author or editor of seven books and over fifty articles on international law. She has recently taught and published on issues of cultural property, particularly in relation to international laws governing the conduct of war. Before coming to Notre Dame she was a professor at Ohio State University, Indiana University-Bloomington, and the George C. Marshall European Center for Security Studies in Germany. She has visited at the University of Cincinnati, the Johns Hopkins University Bologna Center, and the University of Munich. She practiced law with the Washington, DC, law firm of Covington & Burling. She holds a B.A.

from Northwestern, an MSc. from the London School of Economics, an LL.B. from Cambridge, and a J.D. from Columbia.

Robin F. Rhodes is Associate Professor of Art History, concurrent in Classics, at the University of Notre Dame and Principal Investigator of the Greek Stone Architecture at the Corinth Excavations of the American School of Classical Studies at Athens. His research and writing focus on the architecture and archaeology of Greece, particularly that of Corinth and the Athenian Acropolis. His most recent work includes creating and curating a large-scale, interactive exhibition of the process and results of his work on the seventh-century BCE temple at Corinth. He has been the NEH Senior Research Fellow at the American School in Athens, the Frederick Lindley Morgan Chair of Architectural Design at the University of Louisville, and the Ernest R. Graham Lecturer in Classical Architecture for the Archaeological Institute of America and has taught at Bowdoin College, Yale University, Columbia University, and Notre Dame.

Marcia Rickard is Associate Professor of Art History at Saint Mary's College. She has participated in organizing exhibitions and catalogues for exhibitions at the Snite Museum of Art, the Museum of Art at the Rhode Island School of Design, and the Moreau Galleries at Saint Mary's College. She has been a consultant for older visitors and lecturer for the Department of Museum Education at the Art Institute of Chicago. For fifteen years she has taught a course on museums and cultural politics. Her current research is on the artist Jean Charlot.

Kimerly Rorschach is the Mary D. B. T. and James H. Semans Director of the Nasher Museum of Art at Duke University. She is also adjunct professor in Duke's Department of Art, Art History and Visual Studies and chairs Duke's Council for the Arts. She is the former director of the University of Chicago's David and Alfred Smart Museum of Art and has held curatorial positions at the Philadelphia Museum of Art and the Rosenbach Museum and Library in Philadelphia. She is a member and former trustee of the Association of Art Museum Directors and chaired its government affairs committee

from 2002 to 2004. A Fulbright Scholar, Rorschach holds a Ph.D. in Art History from Yale University and a B.A. from Brandeis University.

C. Brian Rose is James B. Pritchard Professor of Archaeology and Curator-in-Charge of the Mediterranean Section of the University Museum of Archaeology and Anthropology. Since 1988 he has been head of Post-Bronze Age excavations at Troy, and is English language editor of *Studia Troica*, the annual journal of the Troy excavations. His new survey project in the Granicus River Valley focuses on recording and mapping the Graeco-Persian tombs that dominate the area. His research has also concentrated on the political and artistic relationship between Rome and the provinces. He is vice president of the American Research Institute in Turkey, president of the Archaeological Institute of America, and a trustee of the American Academy in Rome. He is currently finishing the final publication of the architecture and architectural decoration of the Roman houses at Troy.

Charles Rosenberg is Professor of Art History at the University of Notre Dame. His primary area of research has been in the Italian Renaissance, with a particular orientation toward matters of patronage. He is currently editing a volume for Cambridge on the art produced in Northern Italy during the Renaissance and is working on a catalogue of Rembrandt prints held by the Snite Museum of Art. Recently, he has turned his attention to the history and function of the museum as a political, social, and cultural institution. In 2006 he delivered the Case Western/Cleveland Museum of Art's Buchanan Lecture on the topic "Varieties of the Museum Experience."

Stefano Vassallo is Head Archaeologist of the Ministry of the Cultural Heritage and Environment of Palermo. He has directed numerous excavations in north-central Sicily, the most important of which are in the Greek colony of Himera, in the indigenous Sicel centers of Colle Madore e Montagna dei Cavalli, and at the Byzantine fortification of Kassar di Castronovo di Sicilia. He has focused with particular intensity on the site of Himera, on the development of its town plan from Archaic through Classical times, its fortifications, and the Greek necropolis. Of similar interest to him has been the in-

teraction between the indigenous Archaic Sicilians and the colonial Greeks. He has curated diverse archaeological exhibitions organized by the Ministry of Palermo and has been in charge of the preparation of the archaeological museum of Himera and of other minor Sicilian museums.

Charles K. Williams II is the foremost American excavator in Greece of the later twentieth century. For thirty-one years he was director of the Corinth Excavations of the American School of Classical Studies at Athens. There he trained several generations of American archaeologists in Greece in the techniques of field archaeology. Under him, Corinth served as a paradigm of forward-thinking archaeological technique and approach, and of interdisciplinary study. Before becoming director at Corinth, he served as site architect at Mycenae, Nemea, Porto Cheli, and Gordian in Turkey. He has been a trustee of the University of Pennsylvania and chairman of the Board of Trustees of the American School of Classical Studies at Athens. He has been awarded the Archaeological Institute of America's Gold Medal for Lifetime Achievement for his excavations, scholarship, and teaching.